NIGHT PHOTOGRAPHY SIMPLIFIED

A MODERN PHOTOGUIDE

NIGHT PHOTOGRAPHY
SIMPLIFIED

by

The Amphoto Editorial Board

AMPHOTO
Garden City, New York 11530

ISBN-0-8174-0199-7

Second Printing, July 1976
Text printing and binding by Capital City Press, Montpelier, Vermont

CONTENTS

INTRODUCTION

When the sun sinks below the horizon, your hopes for good photographs need not sink with it. Night will provide you with some of your finest moments in photography. And night will offer you many subjects unavailable to you during the day: pictures of the moon, stars, fireworks, light patterns, etc. Subjects which often appear dull or uninteresting in daylight come alive after dark.

Night takes on a special aura all its own, cloaking the world in beauty, mystery, excitement—and sometimes loneliness. Your camera can capture these moods and give you photographs which will add a great deal of pleasure and adventure to your picture-taking hours.

For some reason many people who own cameras and who get so much pleasure out of them during daylight hours seem to fear photographing at night. "It can't be done," they say, "at least, I can't do it. It's too hard." All you can say to these timid souls is that their fears are unfounded. You *can* take pictures at night. In fact, you can take *great* pictures at night. The aim of this book is to show you how to get the best out of equipment and night subjects; to expose to you the wonderful world of nighttime photography—and to help you to expose it.

Photographing out-of-doors at night pre-sents more problems and requires a better knowledge and understanding of your equipment than any other condition, for there is much less chance of snapping carelessly and getting an image on film. In order to create unusual, dramatic evening shots, you will need to know the best choice of camera, the medium and high-speed films to use, which developers to use for extra speed or special effects, how to develop by inspection when difficult working conditions suggest this method, how to choose and use a meter, or when to rely upon educated guesswork for "available darkness" situations, when to use a tripod, and how to change ASA ratings.

Throughout this book we have endeavored to give accurate technical data under each illustration to provide you with a general guide for specific photographic settings. Perhaps you will use these as a jumping-off point for your own exposures. In unfamiliar picture situations, we suggest you take three exposures, one at the recommended setting, one under and one over. Keep accurate notes at the time of shooting and then match these with your best results. Then you too will develop the "educated guess" which, combined with correct metering, will guide you in all future night shooting.

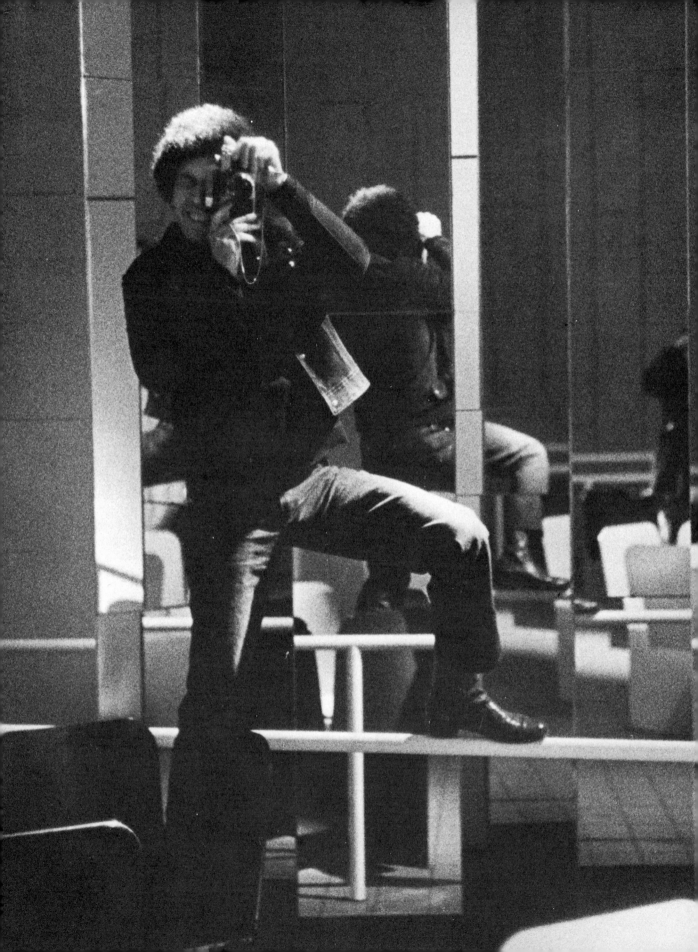

1

WHAT YOU NEED TO KNOW

Here, an agile night photographer achieves a higher vantage point. His compact 35mm camera and comfortable clothing are both valuable equipment. Photo by Patricia Maye.

YOUR CAMERA AND LENS

You will probably take your first night pictures with whatever equipment you already own. All well and good. Any adjustable camera can be used successfully for night photography. However, as you expand your equipment, you may well take the following points into account as you make your selection.

Night picture taking is often done as an adjunct to some other activity—sight-seeing, theater-going, attending the school play, commencement exercises, or sporting event, and so on. The lighter your equipment, the more easily portable it will be on such dual-purpose trips. The 35mm camera is compact and inconspicuous. With its normal lens, plus an auxiliary telephoto or wide-angle lens, it can be easily toted in a small camera bag. Their compact size combined with the large selection of fast films and large aperture lenses available have made 35mm cameras the favorites of professional photographers specializing in available- or low-light shooting.

The choice between the single-lens reflex and rangefinder 35mm cameras is one of personal preference. Each type has its champions and its detractors. With the SLR, viewing is done directly through the lens. The image enters the camera, strikes a mirror, is reflected up into a prism and appears in your viewer just as it will appear on the film. The brightness of the image in the viewer is affected by the lens and f/stop in use. With the rangefinder system, viewing and focusing are done through a window separate from the lens which allows for a brighter image and quick focusing whatever the lens or f/stop in use might be. While the brightness of the image is unaffected by the lens when using the rangefinder, so is the size. When shooting with a long or telephoto lens you'll be focusing and framing on but a small area in the center of your viewer. The choice between SLR and rangefinder must remain yours, but, for its compactness and versatility we recommend the 35mm camera.

Large format cameras are, of necessity, larger, heavier, and more conspicuous. Smaller "subminiature" cameras, which can be as small as a pack of cigarettes, do not have the wide variety of films and lenses available, and the push processing and increased grain so often basic to night photography make even moderate-sized enlargements from their correspondingly small negatives less than precise or detailed.

The field of lenses is perhaps the most bewildering to the beginner and amateur photographer. Brand names abound. Camera manufacturers make lenses for their own cameras and lens makers manufacture lenses that will fit a number of brands.

There are three standard lens-mounting systems—bayonet, screw-thread, and breech-lock. Bayonet lenses fit into flanges on the camera body and are attached with a quarter twist; screw-thread lenses mesh into matching threads on the body; breech-lock lenses fit into flanges on the body and are held in place by a ring which is turned to secure them. You can use any lens compatible with your mounting system on your camera body. And, incompatible lenses can often be fitted to your body with an adapter ring. Thus, the vast supply of lenses is wide open to you.

The primary criterion in choosing a lens for night photography is its "speed." A lens is said to be "fast" or "slow" depending on the size of its maximum aperture. Aperture and f/stop are inversely related. The smaller the f/stop inscribed on the lens, the larger its maximum aperture and the more light it is able to admit. Lenses are now available with settings of f/1.8, f/1.4, or even f/1, but they are expensive. A more reasonably priced f/2 or f/2.8 lens, used with the new fast films and special developers, should be sufficient for your night and available-light shots.

For full coverage of almost any shooting situation you should expand your kit to include moderate wide-angle and telephoto lenses in addition to your normal lens.

FILMS FOR NIGHT PHOTOGRAPHY

A wealth of good films from many countries is available to today's photographer. Most of the high-speed emulsions have appeared within the last five to ten years to complement fast-operating, light-weight camera equipment. Hence, the boom in "available light" photography. Three out of four night scenes photographed in past years required a tripod and lengthy time exposures; most of these can now be easily taken at handheld speeds. The big questions are what film, then what developer, to choose out of the wealth of materials available? Any of these films will give fine results in the hands of a competent photographer. And some films are better than others in various special situations. But since we are exponents of the "simplify your working conditions so you will have more time to shoot" school, we should first tell you how we work. About 65% of the time, we use Tri-X, and Plus-X second and occasionally Panatomic-X in bright daylight conditions. Since the bulk of our work is with available light, often under impossible conditions, we use a standard rating with Tri-X of 1200 ASA for development in Acufine —which is the best high speed-fine grain combination we have found to date.

When film is forced through shooting and/or developing, the image is degraded and the grain exaggerated. With all developers except Acufine and Diafine, Tri-X at 1200 ASA is considered a pushed rating since Kodak places its normal exposure index at 400. However, 1200 ASA is not a pushed speed for Tri-X in Acufine but the rating that produces the maximum quality for this film-developer combination. Pushing starts above this point. (A one-stop push changes the film rating to 2400 ASA.) Acufine produces a remarkable image quality of high acutance, a full tonal range with detail in shadows and highlights, and little blocking in the highlight areas—one of the big problems in contrasty available light work. The grain is both fine and sharp-edged though it does become apparent (as with any

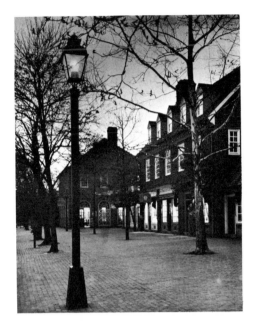

This twilight study was made with a large-format, 4"x5" camera for fine detail in enlargement. With careful exposure and developing equally fine results can be achieved with 35mm cameras. Photo by Mary Eleanor Browning, Photo Trends, Inc.

developer) in exceptionally large blowups. Because of its sharp edge, however, this grain is not objectionable. Acufine works equally well with other high-speed films that are now widely available and surprisingly enough gives excellent results with fine-grain Panatomic-X. It is a good all-purpose film developer with short developing times. We develop all films at 70° but use the time suggested by the manufacturer at 68° to arrive at our version of a normal negative.

When light conditions permit us to work with Tri-X at 400 ASA, we develop in Microdol-X (the 1:1 method) for extremely sharp, fine-grain results. We never use straight Microdol because it has less pushing power and is much grainier for 35 mm and 2¼ x 2¼ film formats.

Diafine, a two-bath developer, is designed to yield fine grain and maximum acutance at pushed ratings. It is supplied in powder form to mix into two solutions. The first solution soaks up the developing agent (3 minutes); the second bath, with the activator, develops the image for another three minutes. Developing time remains the same at any temperature between 65°–85° but 68° is the preferred minimum. Performance too often varies with local water supplies, so mix your chemicals with distilled water for repeated stability. Time and temperature are not critical, but be sure to keep all other solutions at the same temperature ±3 degrees. Use a water rinse rather than an acid stop bath after developing because the second bath is alkaline. All films can be developed together—slow- as well as high-speed emulsions. Diafine is designed to bring all films to full development in three minutes at 68°F. Increases in time or temperature will produce no practical effect on results. When lighting conditions are very bad, we rate Tri-X at 2400 and develop in Diafine for the extra speed. Developing Tri-X rated at 1200 in Diafine is disastrous. The highlights block up and the grain is enlarged, because 2400 for

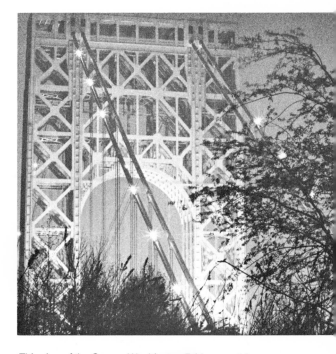

This view of the George Washington Bridge was taken on a misty night. The photographer deliberately overdeveloped his film to increase the grain and sense of moisture suspended in the air. Photo by Gerald Healy, Photo Trends, Inc.

Tri-X in Diafine is not a pushed speed but the rating that produces the maximum quality in this developer.

When we occasionally use Plus-X at night it is rated at 200 ASA and developed in Micro-dol-X 1:1 or at 400 ASA and developed in Acufine.

Again, let us caution you that many films are excellent for night shooting and our choice may not necessarily be yours. If you've had good results with your present film-developer combination, stick with it. It's much better to standardize on one film-developer combination than to switch around even if your film lacks some of the qualities you expect from it. We have standardized on Kodak films because, from our experience, they seem to have extremely wide latitude, high acutance, great speed, rugged emulsion characteristics, and are readily available.

In the medium-speed category Ilford will help you achieve fine-grain pictures at dusk or dawn approaching the quality of Mary Eleanor Browning's Williamsburg scene, page 11, exposed on 4×5 film. These two films have the finest grain in the medium-speed category and in many ways approach the resolution of the extremely fine-grain, slow-speed films. In addition, they have great sharpness, contrast and good exposure latitude for those occasional meter errors—an ability that diminishes as the speed of the film is lessened. Extremely fine-grain films have not been included in this book because their very slow speeds necessitate long time exposures in most instances.

Of the faster films, Kodak 2475 Recording Film and Kodak Royal-X Pan might be considered special-purpose, high-speed materials. They have a surprising ability to tolerate over-exposure with less damage to grain and sharpness than the other high-speed films. Nevertheless these overexposed negatives are not equivalent to carefully exposed and processed negatives, so use the meter carefully. Overexposure and/or overdevelopment destroys fine

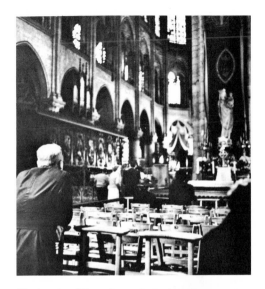

The interior of Notre Dame Cathedral offered the photographer little available light for this shot. Even with Royal-X Pan rated at ASA 800, she had to brace the camera against a wall and expose for $\frac{1}{10}$th sec. Photo by Kathy Wersen.

grain, image sharpness or acutance, and detail in the highlights. However, in creative photography rules are made to be broken. The interpretations of night often are enhanced by large grain, as illustrated in Jerry Healy's misty bridge shot on page 12. In addition to getting large grain by overdevelopment you can also emphasize it by printing on #5 or 6 paper (see Flamenco series, pages 64, 70) or by choice of film. High-speed materials are not designed to produce fine grain. And, if it's grain you're after, excellent results are attainable with Rodinal developer. It is a red liquid concentrate that is diluted with varying amounts of water, according to the film used and the contrast you want. The lower the dilution, the greater the grain produced. In concentrated form Rodinal has long shelf life. In a 1:50 dilution it gives sharp, crisp results with films rated as high as 2000 ASA. Acufine also works well when you prefer the lower ASA rating of 1200. Grainy, high-speed films in combination with grainy developers can look pretty wild.

Kodak Royal-X Pan was introduced in 1958 for 120 and larger format cameras. Its ASA was first established at 650, then changed to 1250. At the lower end of its speed scale, correctly-exposed and normally-processed, Royal-X is capable of producing unbelievably sharp, fine-grain results. Note the interior view of Notre Dame, page 13. The light was so dim that it was difficult to see your hand in front of you.

The recommended developers for Royal-X Pan are *DK*50 and *DK*60a. These produce remarkable highlight and shadow detail, as well as a tight, sharp grain pattern, and they have excellent shelf life. The film can be pushed to very high ASA ratings. Diafine allows for Royal-X Pan rated at 3200, Ethol UFG, at 2000. We consider Diafine, Rodinal, and DK50 special-purpose developers and the rest general-purpose developers.

D76 has been a favorite for medium and fast films for years and is often used as a standard of comparison with other new developers. It has wide latitude and produces a sharp, crisp medium-fine grain with slightly finer-grain results when used as a one-shot developer in 1:1 dilution. Plux-X at 200 and Tri-X at 400 are excellent in it. D76 keeps well and is economical.

Microdol-X can be used straight or diluted. We like it best in 1:1 dilution as a one-shot developer. Its soft-working qualities produce a wide tonal range, fine definition and exceptionally fine grain (better than D76) with an economical price tag.

Ethol UFG produces brilliance and negative sharpness with good pushing potential though highlights will block more at elevated ratings. It was the favorite of the "available light" photographer until Acufine came along with its faster normal ratings, latitude and fine-grain capabilities. However, it is considered in the same class with Acufine and works well with many different films.

Promicrol falls into the above category, too, and is an extremely fine-grain, medium-contrast developer. It does not have as good exposure latitude, so expose and develop carefully. Also, shelf life is nil, so mix a fresh batch each time you develop. Promicrol pushes films well without highlight blocking and is similar to Microdol-X in its many fine characteristics.

One film-developer combination (if you do not already have your own) should start you on the way to successful night shooting your first time out. We consider this choice to be step number one, for it will give you the film index for your final results. Careful darkroom processing will back this up to achieve your interpretation of life after dark.

The cat on the opposite page was photographed on Kodak's 2475 Recording Film. The print displays the film's tendency toward graininess. Photo by Patricia Maye.

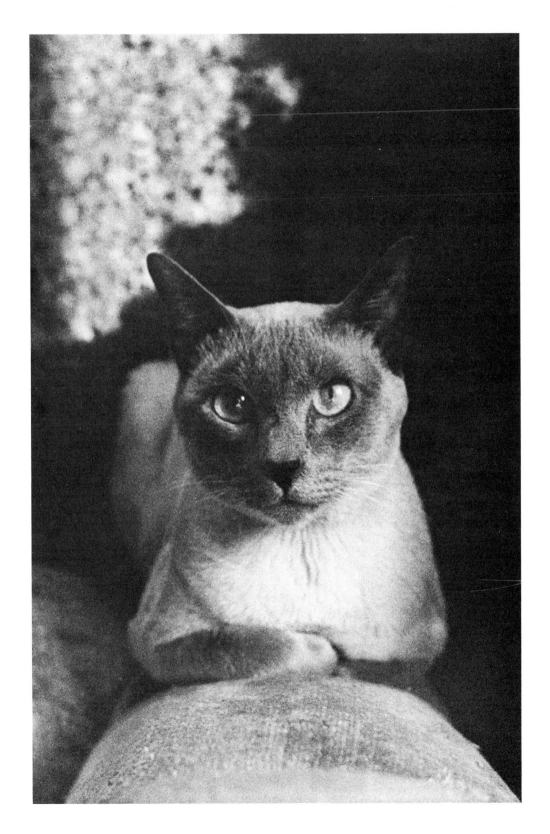

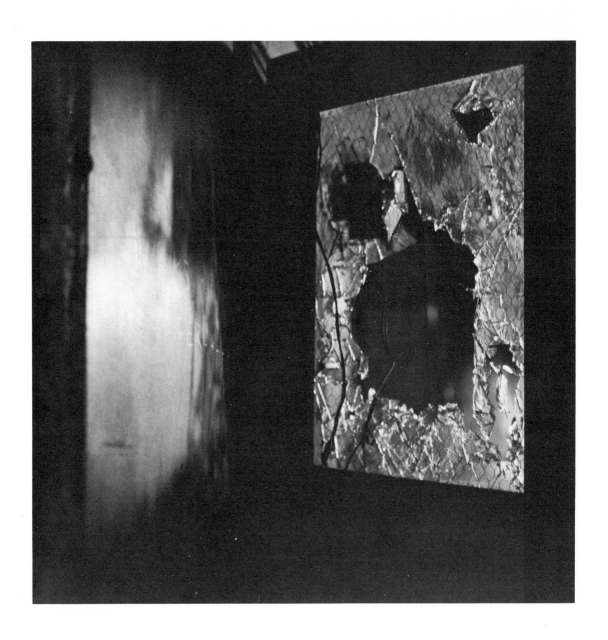

This cracked pane of glass was discovered on a West Side pier after the photographer saw some friends off on a cruise. There was little light but Ilford HP4 push-processed to a rating of ASA 800 produced a printable negative. The shot was made on 120 film and grain remained negligible even at a 3x enlargement. Photo by Patricia Maye.

POPULAR BLACK-AND-WHITE FILMS

Low Speed Films

Adox KB-14	ASA 20
Agfapan 25	25
Panatomic-X	32
Adox KB-17	40
Isopan IF	40
Ilford Pan F	50

Low speed films are useful when you wish fine detail rendition. Since time exposures are so often necessary in night photography anyway, many photographers use low-speed films for landscape and architectural shots.

Medium Speed Films

Adox KB-21	100
Agfapan 100	100
Isopan ISS	100
Neopan SS	100
GAF 125 B&W	125
Ilford FP 4	125
Plus-X Pan	125
Neopan SSS	200

Medium-speed films serve well for shots at dusk and dawn and brightly lit displays. Like low-speed films they are fine for time exposures.

High Speed Films

Agfapan 400	400
Ilford HP 4	400
Isopan ISU	400
Tri-X Pan	400
GAF 500 B&W	500
2475 Recording Film	1000

High-speed films really make almost any situation fair game for the night photographer. The ASAs listed are base ratings. All these films can be pushed in the processing to achieve ratings of 2 to 3 times normal.

COLOR FILMS

Successful night-time color pictures are slightly more difficult to produce than black-and-white shots, but with careful exposure and realistic shooting they are quite possible even for the beginner. If color prints are the end result you seek, use color negative film. For color slides, choose a color reversal film. Prints can be made from transparencies, but the printmaking requires an extra step, the making of a negative, extra expense, and diminished quality.

Choose a film with an ASA rating high enough for the light situations you are apt to encounter. A slow film will prove adequate for brightly lit or flash-lit shots but if real available-light shooting is your plan, choose a high-speed film. Push processing is possible with color films just as with black-and-white. Kodak's High Speed Ektachrome can be rated at 400 ASA and GAF's 500 Color Slide Film, at ASA 1000. (Special mailers are available from your processors at an additional cost.)

Always make certain that your color film is appropriate to the light source. Most color negative films are now called "universal" meaning that they can be used with any light source. This is made possible by the corrections possible in the printing stage. No such correction is possible with color slide films. Filtering will convert a film for use with a light source other than that for which it was designed. But, filtering cuts down the amount of light reaching the film and necessitates an exposure increase. Daylight films can be used at night with blue flash bulbs or electronic flash. Tungsten films are meant to be exposed by studio floodlights. They will produce the most naturalistic looking results when household lamps serve as the light source.

POPULAR COLOR FILMS

Color Negative Films
(for prints)

Agfacolor CNS Color Print Film	ASA 80
Dynachrome for Color Prints	64
Fujicolor N-100	100
GAF Color Print Film	80
Kodacolor / II	80

Color Reversal Films
(for slides)

Agfachrome / 64	64
Agfachrome 50S	50
Dynachrome 25	25
Dynachrome 64	64
Fujichrome R-100	100
GAF 64 Color Slide Film	64
GAF 200 Color Slide Film	200
GAF 500 Color Slide Film	500
Ektachrome-X	64
High-Speed Ektachrome	160
Kodachrome / 25	25
Kodachrome / 64	64

HOW TO CHANGE ASA RATINGS
AND EXPOSURE SETTINGS

Computations are a necessary part of every photographer's life. Suppose you are shooting with two cameras, one loaded with High Speed Ektachrome B 125 ASA and the other loaded with Tri-X rated at 400 ASA. If your cameras both have built-in meters you're set. But suppose you have only one light meter. The difference between 125 ASA and 400 ASA is $1^2/_3$rd f/stops. In computing changes in film speed, multiply by 2 for the equivalent of 1 stop faster or divide by 2 for one stop slower. 100 ASA — 200 ASA — 400 ASA — 800 ASA — 1600 ASA. Close down one f/stop or shoot at one shutter speed faster each time the film is doubled. ASA 400 compared to 1200 ASA is the equivalent of $1^1/_2$ stops.

Now back to our first example of color and black-and-white films at two different speeds. Always set your meter reading for the color film since its exposure is more critical and black-and-white film has more exposure latitude. The scene we are going to shoot meters at f/4 and 1/60th for 125 ASA. You can figure $1^2/_3$rd stops or speeds faster for the black-and-white film, which would require setting the f/stop at $f/2.8 + {}^2/_3$, and 1/250th. If you actually move your aperture selector dial $^2/_3$rds of the way past f/2.8, the diaphragm will accurately close by this amount. Or more easily figure two stops difference and shoot at f/4, 1/250th or f/5.6, 1/125th. Up to $^1/_2$ stop in computing black-and-white films is not critical.

Doubling the ASA film rating is the equivalent of shooting one shutter speed faster or closing down one f/stop.

NOTE: To absorb this instruction more easily, we suggest you take out your camera and your meter and follow the instructions point-for-point on your camera and meter dials.

DEVELOPING BY INSPECTION

There will be times in night photography when the illumination will be so dim that you have to guess at the exposures or rate film higher than its normal exposure index. If the developer instruction sheet doesn't list a longer developing time for this pushed rating you will need to develop by inspection to arrive at the new correct developing time.

Normal developing is done by time and temperature; development by inspection is a procedure in which black-and-white film is developed in complete darkness for about 50% of its total time. Then the photographer checks development progress by a safelight covered with a Kodak Wratten #3 dark green filter. The film is viewed once again just before it is due to be transferred to the short stop, to determine if additional development is needed. Inspection developing will save hours of difficult printing.

Hold the film four feet away from the safelight, emulsion side up. During development the emulsion surface looks creamy. As development progresses the highlights will become quite dark. When you can see details in the shadow areas the film is ready to come out. However, after fixing, you may find that the density and contrast appeared higher under the safelight than they really are and your negatives are underdeveloped. Only repeated experience can teach you just what to look for.

If you have trouble reading your negatives under the green safelight, use a film desensitizer such as the one put out by Kodak (Pre-Bath Type). Soak the film in a solution of desensitizer for about two minutes in a light-tight tank (at developer temperature). Pour out the desensitizer, rinse film with water, then pour in developer. The film can then be viewed at various intervals during development under an amber safelight such as Kodak Wratten OC or OA used for Polycontrast or Varigam papers. Viewing can safely take place four feet away from a safelight with a 25-watt bulb. The brighter illumination will make the negative much easier to read. By carefully noting the new development time for the pushed ASA rating, you will be able to develop future rolls for this pushed rating by time and temperature.

The portrait of the boy on the opposite page was made by the available light of a small lamp. The shutter speed was held at a too-fast $^1/_{125}$th sec. because asking the boy to pose would have ruined the naturalness of the shot. To insure an image, the photographer clipped off a few frames from the start of the roll and processed them by inspection. When she discovered the correct developing time, she processed the remainder of the roll. Such a clip test takes time but insures results. Photo by Patricia Maye.

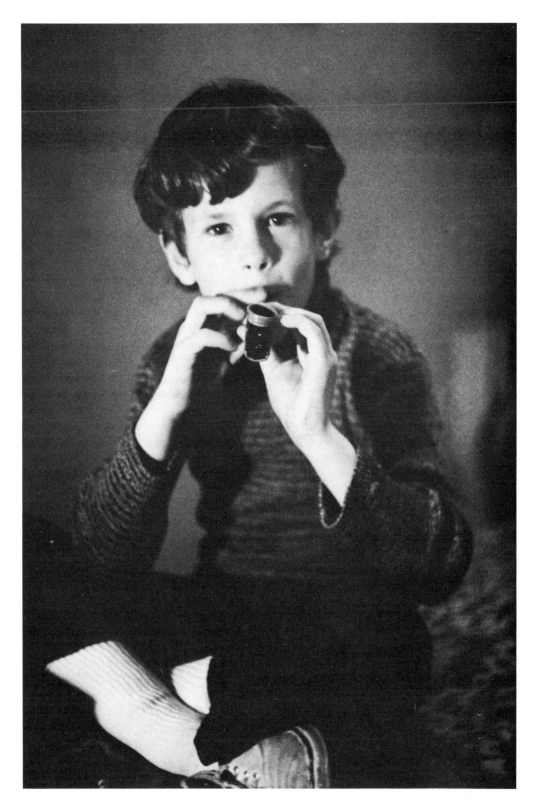

EXPOSURE METERS

The light meter is your most important accessory, for the quality of the camera, lens or enlarger does not matter if the film is under- or overexposed. Until the advent of the cadmium sulfide battery most night exposures (except under bright light conditions) were made by trial and error and finally by experienced guesswork. Even now, though there are meters that read "by the light of the moon," experience still plays a part in the determination of many "available darkness" shots.

Originally, the only practical photocell in photography was the selenium. Light hitting this cell generates electricity. A meter movement measures the current, which relays f/stop and/or shutter speed for a given preset film sensitivity. One of the selenium meter's drawbacks is low sensitivity. The cell doesn't generate much current, even with boosters.

With the introduction of the Lunasix meter came the revolutionary cadmium sulfide (or CdS) cell. This cell doesn't generate current, but in series with a battery it reacts as a valve to the battery's current. Thus the more light that strikes the CdS cell, the more current flows into the meter movement and the greater the needle deflection. The CdS cell reads a narrower angle of view, providing more accurate readings, and allowing for more ruggedness and sensitivity to low light levels than most selenium cell meters, even with boosters.

If you now own a selenium Weston Master IV or V, don't feel you have to run out and buy a new CdS meter. Westons held their own in comparative tests run with the best of the newer meters.

There are three types of exposure meters— reflected-light, incident-light and spot. The reflected-light meter reads the light reflected from the subject. An overall reading can be taken by pointing the meter from the camera position in the direction of the subject. Selective readings can be made up close to bring out important shadow or highlight details. A more accurate average reading can be determined from two readings—one from the shadow, the other from the highlight areas of your subject. When you cannot get close to your subject you can take a substitute reading from your hand, held in the same light condition as the subject. This is to assure the proper exposure for good skin tones. For correct shadow details (when photographing a dark animal, etc.) take the reading from dark fabric or surface in similar light conditions. At extreme low-light levels, with all but the ultra-sensitive CdS meters, make a close-up reading from a white surface at subject position. Then expose at five times the indicated setting.

The incident-light meter measures the light that falls onto the subject, giving an average brightness reading. Hold the sphere-shaped light collector in front of the subject, pointing it toward the camera lens.

The reflected-light spot meter's special advantage is its narrow angle of coverage (as narrow as 1°) which allows you to read several small areas, compare them, then choose the setting to give you exactly what you want. (This is similar to the reflected-light technique.) The disadvantage is that you may miss proper exposure for other important subject areas and lose valuable shooting time while taking many small-area exposure readings and then determining which to use. To arrive at quick average exposures, take the meter reading from a light gray area of the subject. Because of the narrow angle it measures accurately from a distance, the spot meter is excellent for theater and sports events. And, in very low light levels, use the spot meter to take a reading from a white subject, such as a shirt, from some distance. Again, expose at five times the indicated setting.

For medium to well-lit street shots at night a good CdS meter will determine your settings. If you want detail in the shadows, meter a dark area or take a reading from your hand and shoot at 2, 3 and 4 times more than the

HANDHELD METERS FOR LOW LIGHT LEVELS

METER	Angle of Acceptance	ASA	Shutter Speeds	f/stops	Other Features
Bewi Super L	35°	12-3,200	1 hr.-1/1000 sec.	1-45	CdS meter. Measures reflected light, incident light with converter. Battery check. Pocket lamp for dim light readings. Price includes case, neckstrap, batteries.
Gossen Luna-Pro	30°	6-25,000	8 hr.-1/4000 sec	1-90	CdS meter. Measures reflected light, incident light via converter. Price includes case, neckstrap, batteries. 7½-15° spot attachment
Honeywell Pentax 1°/21°	Measures 1° spot from 21° field of view	6-6,400	4 min.-1/4000 sec.	1-128	CdS meter. Measures reflected light. Built in dual level booster, illuminated exposure scale. Price includes case, wriststrap, batteries.
Leitz Metrastar	18°	3-12,500	8 hr.-1/4000 sec.	1-45	CdS meter. Measures reflected light, incident light via converter. Battery strength indicator. Indicator-needle lock. Price includes case, neckchain, battery.
Minolta Auto-Spot 1°	1° from 8° field	3-25,000	30 sec.-1/2000 sec.	1-45	CdS meter. Measures reflected light. Built-in reflex viewfinder. Battery check. Full focusing.
Sekonic Model L-206	10°	12-3,200	8 sec.-1/2000 sec.	1-45	CdS meter. Measures reflected light. Indicator-needle lock. Dual range. Battery check. Price includes case.
Sekonic L-228 Zoom	8.2-28°	0.1-16,000	64 sec.-1/1000 sec.	1-32	CdS meter. Measures reflected light. Eye-level viewing. Dual range sensitivity, built-in booster. Price includes case, wrist strap, batteries.
Soligor Spot-Sensor	1°	6-12,800	30 min.-1/4000 sec.	1-128	CdS meter. Measures reflected light. Eye-level reflex viewing. Zero adjustment. Battery check. Dual sensitivity range. Built-in hand grip, adjustable eyepiece. Price includes case, wrist strap, battery, lens cap.
Weston Master 6	40° high 80° low range	0.1-25,000	2 hr.-1/4000 sec.	.5-64	Selenium cell. Reads reflected and incident light. Indicator-needle lock. Zero adjustment. Price includes case, neck cord, incident-light adapter.
Weston Ranger 9	18°	1.5-25,000	2 hr.-1/4000 sec.	.5-64	CdS meter. Reads reflected light, incident light with converter. Indicator-needle lock. Zero adjustment. Battery check. High-low scales.

EXPOSURE METERS ... continued

indicated exposure.

For bright neon lights, moving lights at fairs, etc., a good starting point would be f/2.8 at 1/30th to 1/250th, for Plus-X at 200 ASA. Pointing the exposure meter at the bright lights will only give you an inflated reading. Exposure meters were not designed to read light sources. They read the light reflected by the subject or light falling on the subject.

Distant scenes at night usually require time exposures. We include a table of suggested settings for different night scenes (page 95) but remember that there is much variation in the available light situations you'll encounter. Use the chart as a starting point for exposures. Consult the technical data from a specific night photograph in this book that is similar to the scene you are about to take. Use the photographer's exposure with a given ASA rating as your guide, then bracket over and under. Take notes and check your results to arrive at your own correct settings and with the particular camera, meter, film, and developer you use.

Be sure to set the film ASA rating each time before you use your meter. If you plan to take many shots in a given area, take all necessary readings first to free yourself for picture-taking. Avoid having to go back for readings in darker or lighter areas. With an incident-light meter don't forget to compensate for a very light or dark subject. With a reflected-light meter, measure for the important tones you want in the final picture. Then select the f/stop-shutter speed combination that will interpret the subject the way you wish to represent it.

TRIPODS

For very low light scenes which require a slow shutter or a time exposure, a tripod is a must. Much has been written on the perils of camera shake and its ruinous effects on negatives. Try taking pictures of a friend, using shutter speeds from 1/60th through 1/4th of a second. Have him hold a card noting the shutter speed. Focus on the eyes to rule out the possibility of inaccurate focus, then make large blowups of just the eyes. From these you will be able to pin down the point at which you began to shake. Then you'll know when to use a tripod. Many professionals can successfully hand-hold a camera up to 1/4th or 1/2 second. With practice you'll be able to improve upon your present point of steadiness for those great pictures that pop up when you're without a tripod.

The heavier the camera, the sturdier the tripod should be to insure complete immobility during exposure. Tripods have telescoping legs which are adjusted to the height of your picture, and are collapsible for easy carrying. The addition of a sturdy, movable center post saves raising and lowering the legs with every change of camera height. If you want to adjust camera angle, you need an adjustable top or pan head. Look for one that swivels completely around, has a lock, tilts up and down, and has a movable base plate that flips sideways and will lock tightly when you want to change from horizontal to vertical framing.

To avoid camera shake on a tripod when depressing the shutter release at slow speeds, use a cable release; this screws into a cable release socket in the camera. Any camera store can tell you which one to buy when you specify your camera make and model. On very windy days, even with a heavy tripod, you may need to suspend a brick or other heavy weight by cord to the underside of the tripod to insure a steady camera.

MISCELLANEOUS EQUIPMENT

A well-organized camera bag can greatly simplify photographing at night. To cut down on confusion, pack only those things you have a real expectation of using. Segregate color and black-and-white film for quick, correct reloading. Pack special items such as cable releases and special effects filters in specific locations in the case for handy access. Replace them in their proper places after use, for quick re-access.

As soon as you realize the added sparkle that rain can lend to your night photographs a supply of small plastic bags should be added to your basic equipment. Remember, you won't be doing quick, in-and-out, daylight shooting. And, a simple, inexpensive, plastic bag raincoat for your camera will make time exposures possible even in the rainiest weather. Just place the bag over the camera with its lens poking through a hole in the front of the bag. The bag can be held in place around the lens with a rubber band. Rip a small hole in the back of the bag to allow access to your viewer and your camera will be able to stand the weather as long as you can.

Finally, don't overlook the one ingredient that night shooting lacks—plentiful light. A small pen-light, pocket flashlight will provide enough illumination for reading meters, camera settings and film data sheets even on the darkest night.

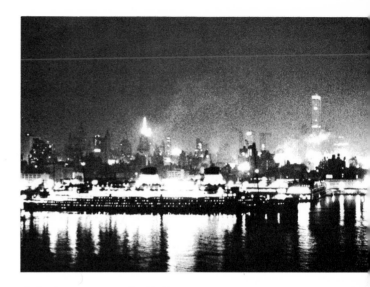

A tripod was necessary for this ¹/₂ sec. exposure. Overdeveloping in undiluted developer increased the contrast between the highlights and darkness. Photo by Gerald Healy, Photo Trends, Inc.

2

PICTURES IN THE TWILIGHT ZONE

The nature still-life opposite was shot at sunset. The low angle of the light emphasized the grain of the wood and the shadows. Photo by Rafael Fraguada.

PICTURES IN THE TWILIGHT ZONE

Some of nature's most exciting displays occur at sunrise and sunset; no two are exactly the same, and each flares and fades with its own particular beauty—beauty which you can capture and record in many imaginative ways with your camera.

Dusk—that hazy, twilight moment just after the sun has set, and dawn—the first glimmer of light as the new day begins—cloak the earth with mystery. Dawn is the time of day most often overlooked by photographers and this is unfortunate, for it offers its own unique mood.

Why not try experimenting with intense-color filters such as orange or red, to exaggerate clouds and darken the sky in the twilight zone? Try fine grain, then very large grain. Practice exposing, then printing, for a complete tonal scale, or underexpose and print on contrasty papers for dramatic effects. Nature at this time of day lends itself to powerful photographic treatments.

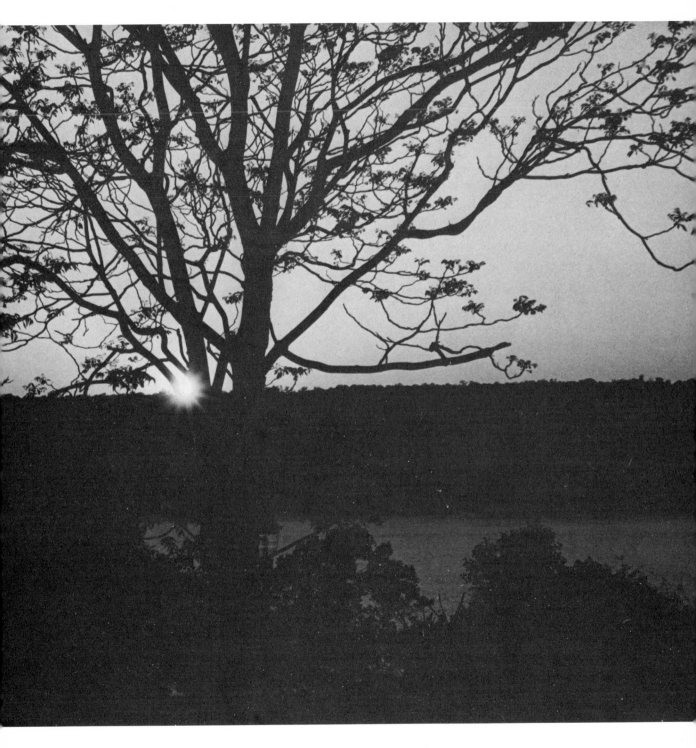

The dramatic landscape above was shot just before sundown with the camera pointed directly into the sun. All detail in the branches and foreground was sacrificed. Photo by Susan Wolf.

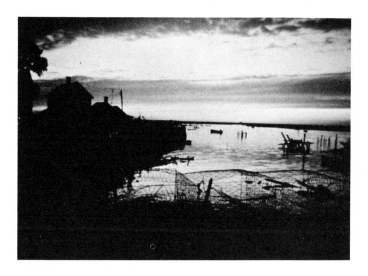

This print was made from a color transparency. The original was a fiery sunset but the contrasts were strong enough to make the scene equally interesting in black and white. Photo by Kathy Wersen.

This starkly silhouetted beach scene was taken about a half hour before sunset. Photo by Kathy Wersen.

Like the scene above, this shot was originally a color transparency. Again, strong contrasts converted to an interesting black-and-white print. Photo by Norman Rothschild.

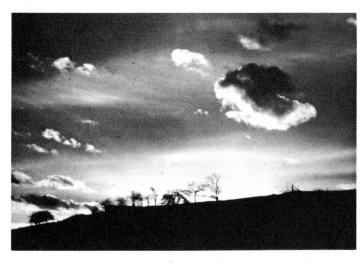

SUNSET AND SUNRISE

In order to photograph these scenes, you must abandon the old rule which states, "Never point your camera directly toward a light source." Incident-type meters are virtually useless here. When your prime interest is the sunset or sunrise, point a reflected-light meter toward the scene, including more sky than foreground—but be sure to shade the meter from the direct rays of the sun. The contrast range in these pictures will be so great that the foreground areas will usually be underexposed.

If people are in the scene, take the meter reading from their faces if you want foreground detail. Also take a meter reading from the sky. If there is too wide an f/stop variation between the two readings and you photograph at the foreground subject f/stop, the sunrise (or sunset) will bleach out. Unless you want this, expose midway between the two readings. Often exposing for the sunset (sunrise) and letting the foreground fall into silhouette will provide the most dramatic kind of pictures. In color photography more vibrant color saturation will result from varying degrees of underexposure.

Remember to take meter readings often when photographing at these times because the light varies from minute to minute. At best, the light at this time of day is tricky. So be sure to bracket two and four stops over and under the suggested meter reading. And be sure to keep records on normal and bracketed settings to arrive at the best exposure guide for your equipment and the special interpretations you are after.

The photographer emphasized the sky and foreground in the novel view of the Cologne Cathedral at sunrise. Photo by Horst Schafer.

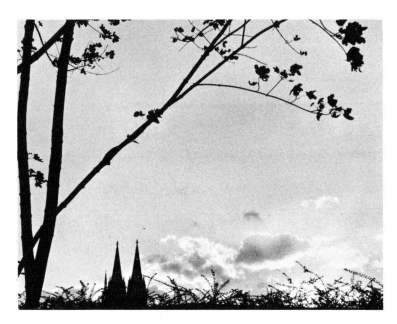

DUSK AND DAWN

Pictures at twilight show more detail in the shadow areas than those taken in the dark of night. Many photographers take their night photos at dusk because there is still enough light to separate mountains, buildings, etc., from the sky, and the lights of cars, houses and buildings are on at this time, suggesting a later hour. In addition to better separation of the planes within a picture, exposures also run shorter.

If you want more of a night effect in your twilight pictures, this can be achieved in the darkroom by burning-in sections of the negative, such as the sky area, or giving longer exposure to the entire negative for a darker print.

Another way of achieving this is by underexposing from one to four or six stops when you take the picture.

When shooting a city at dawn, you will find that most of the lights have been turned off; these pictures will look quite different from your city shots at dusk.

Although most photographers seem to think of these times of day in terms of scenics, don't forget to include people in relation to a rural or city setting for variety in your pictures of the twilight zone.

The photographer staged his shot, "Make the last 'one for the road' coffee", by placing the cup in the road and waiting for a truck to come along. Tri-X, rated at ASA 600, allowed for an exposure of $^1/_{30}$th sec. at f/2.8 in the dim twilight. Photo by Douglas Corry, Photo Trends, Inc.

The photo of the Manhattan skyline opposite was taken by the early morning light. A red filter was used to darken the sky and most of the buildings. The metal building in the center acted like a reflector. Photo by Gerald Healy, Photo Trends, Inc.

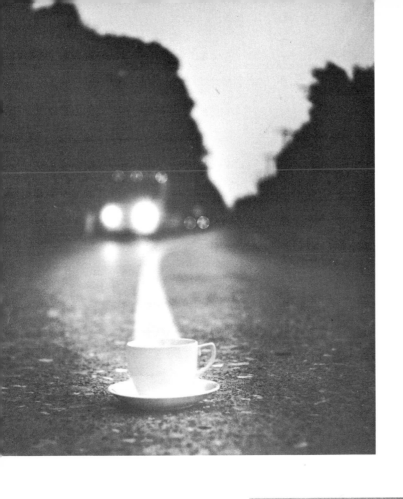

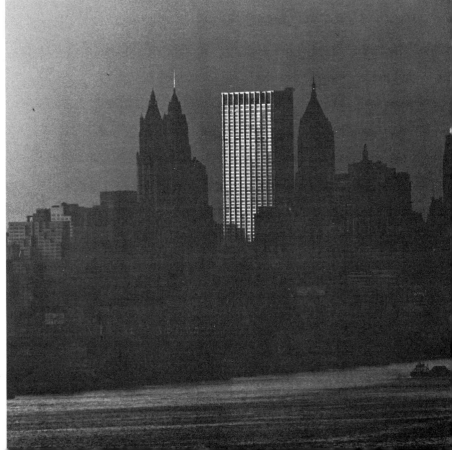

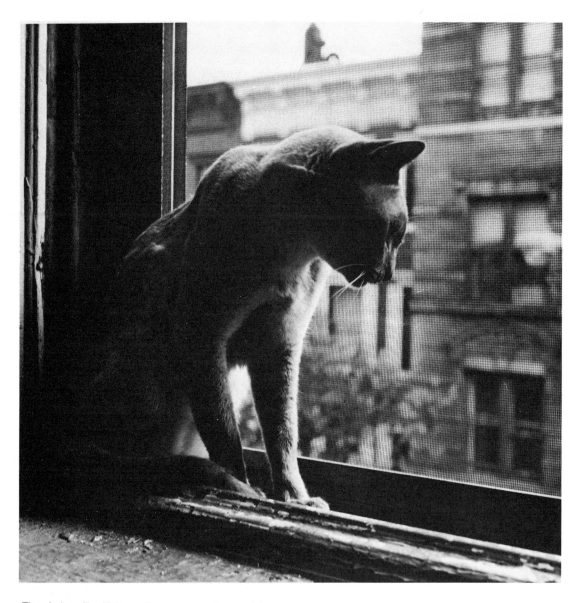

The window sill, with its southern exposure, is one of the cat's favorite perching places. During most of the day, the high contrast between the brightness outside and the darkness within makes it impossible to photograph him as anything other than a silhouette. This shot was made at dusk on Ilford HP4 film, when the contrast between inside and out was diminished. Photo by Patricia Maye.

Atlas stands, facing east, opposite St. Patrick's Cathedral in New York. The photographer went out very early in the day to get this shot. Later, when the sun moves overhead, much of the detail on the front of the statue is lost in shadow. In the afternoon, when the sun moves behind the building behind him, Atlas becomes unphotographable. Photo by Patricia Maye.

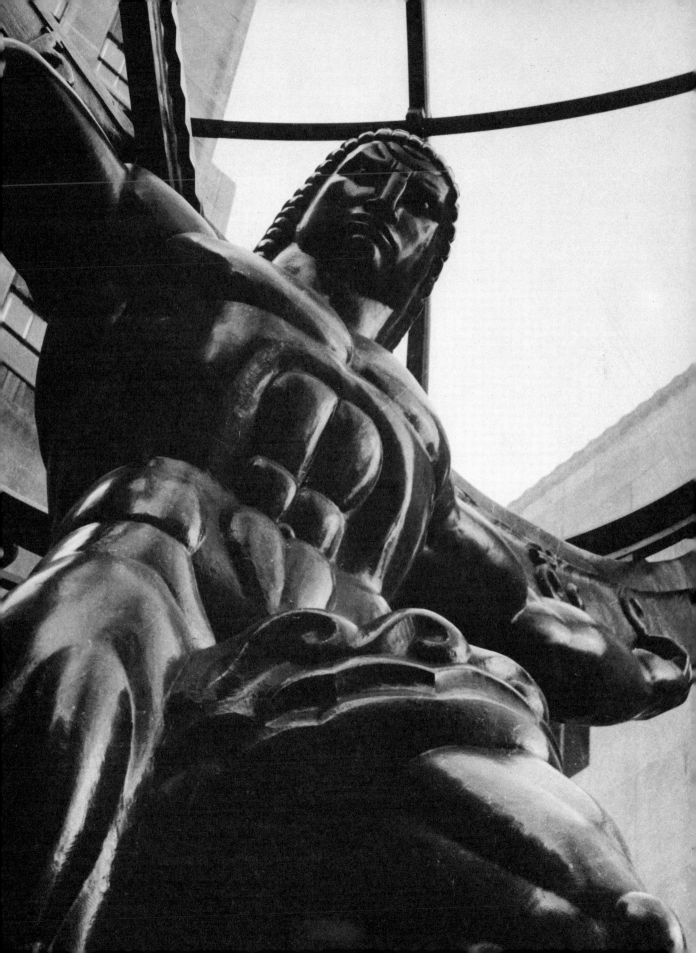

This street scene was shot late at night in downtown Manhattan from within a car. The slightly steamy windshield had a diffusing effect on the street lights. A more obvious diffusion effect can be attained by placing a layer of nylon stocking or special diffusion screens over the lens. Photo by Patricia Maye.

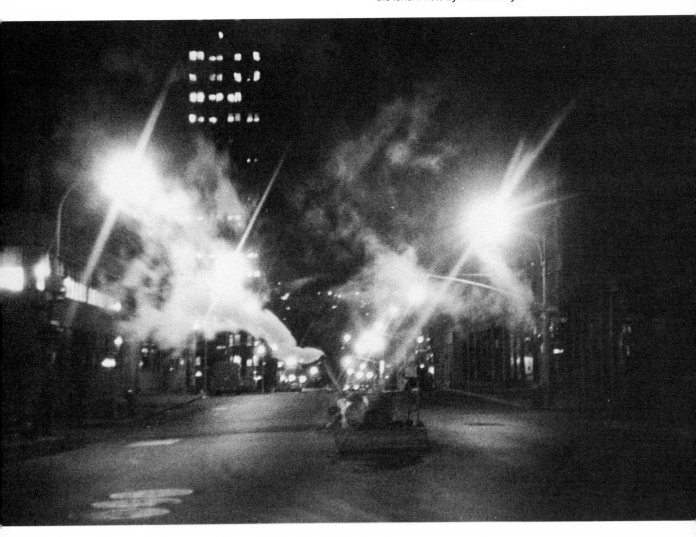

3

DEALING WITH LIGHT AT NIGHT

DEALING WITH LIGHT AT NIGHT

The biggest problem in photographing at night is the wide variety of light sources that must be dealt with. Out-of-doors in daylight your problems concern themselves with sun and shade—but out-of-doors in the evening you will be confronted with moonlight, fluorescent, incandescent, neon, street light, and many others.

Thanks to today's faster lenses and the ability to push film ratings and force development, photographers are able to take photos of almost anything at night.

Since many night pictures contain strong light sources, unusual mood shots can be created by throwing the camera out-of-focus to obtain abstract light shapes and by using diffusion screens or diffraction gratings in front of the lens to break up the light source into interesting patterns. Or, by holding one or two pieces of wire screen or nylon stocking in front of the lens, you can create a "star" around the light. As you experiment with these techniques, you will discover many other ways of dealing with light at night.

The steam from an underground repair site seemed to dance gaily in the cold night air. The shot was made on Kodak 2475 Recording Film and developed normally. Photo by Patricia Maye.

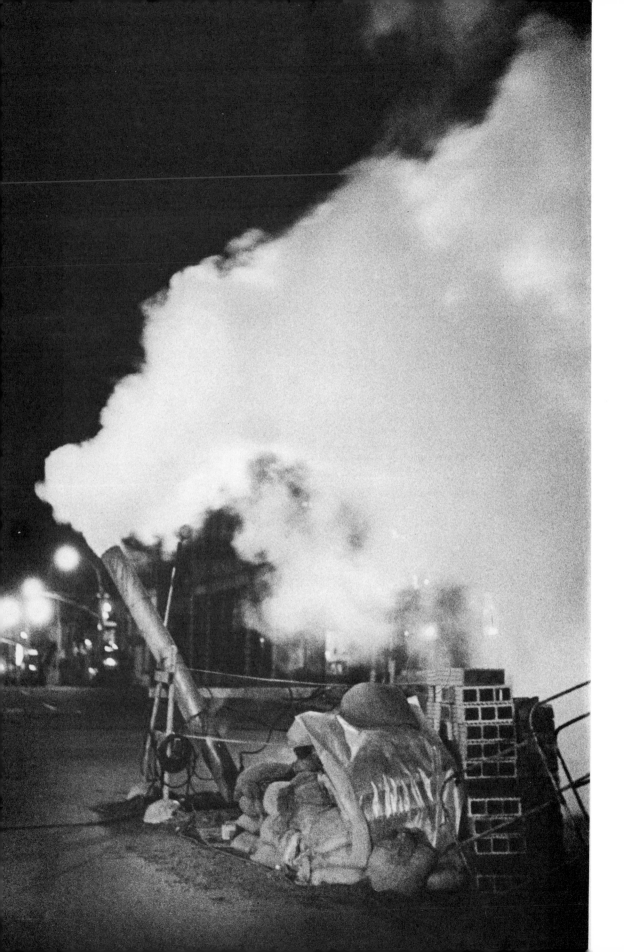

MOONLIGHT

Some of your most exciting night scenics can be taken by the light of the moon—with no additional illumination. Although the moon may seem very bright, it is not a light source—only a reflector of sunlight. Moonlight shots usually require time exposures with a tripod.

To expose for moonlit landscapes including water, start with Tri-X rated at 1200 ASA and set your camera for 6 seconds at $f/5.6$. Then bracket two and four stops over and under. When shooting with shutter speeds of one second or longer you must compensate for reciprocity failure. This means that at shutter speeds of one second and longer a proportionate increase in exposure time ($f/8$ at 12 seconds) will not produce a proportionate increase in exposure or negative density. An increase in time is necessary and exposure meters do not supply this compensation. The average corrections for Kodak black-and-white films are as follows:

Calculated times (in seconds)	Increase exposure
1-2	$^1\!/_2$ stop
3-6	1 stop
7-16	$1^1\!/_2$ stops
17-35	2 stops
36-70	$2^1\!/_2$ stops

When exposing landscapes (without water) by moonlight give at least one stop more than for the above example of $f/5.6$ at 6 seconds. For moonlit landscapes with snow on the ground give at least one stop less ($f/8$ for 6 seconds). To expose cityscapes begin with two stops less ($f/11$ for 6 seconds). This can only be a rough guide at best—experience will be the final teacher.

Watch out when you are including the moon itself in such scenics. The universe is in constant motion, and long time exposures which include the moon will give you a sausage-like image on your negative, showing the path the moon is taking. (See also page 87.)

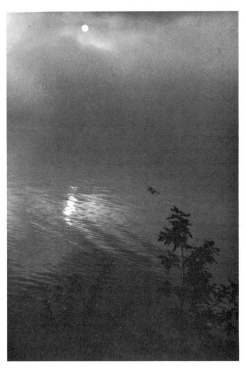

NEON

The brightest lights of the city are the flashing neon signs, and they make dramatic sources to include in your cityscapes. Or, you can photograph them for themselves—in or out of focus. You can also create many abstract pictures in black-and-white and in color by making several exposures on one frame of film.

Neon signs usually overpower surrounding areas and are easy to overexpose. Therefore, bracket two stops over, then 2, 4 and 8 stops under to learn how to capture the effects you want. For shots of people, theater marquees provide a soft, even light similar to an overcast day.

You can also use the marquee lights as a background for silhouette pictures. Place your subject in front of the lights by angling the camera up and expose for the lights (also underexpose one and two stops). This will reduce your foreground subject to a silhouette. Frame carefully and you should arrive at a real show stopper.

The shot on the opposite page, moonlight on the Elk River in Maryland, was made on Tri-X film. Photo by Kathy Wersen.

INCANDESCENT

Not all night photography is executed out-of-doors. By using fast film (400 ASA or higher) and a fairly fast lens (*f*/3.5 to *f*/1.4) you will be able to capture good pictures in dim indoor light without having to boost it or to use flash.

Probably the major sources of lighting in your home will be of the incandescent type—60-, 75- or 100-watt lamps. By placing your subject near a source of illumination or vice versa, you will have adequate illumination for good photographs. A desk lamp or floor lamp beside an easy chair or couch can serve both as good at-home props and perfect light sources. The closer the subject is to the light, without cramping of course, the better. Remember, illumination falls off in relation to the *square* of the light-to-subject distance. A subject four feet from the light source receives only one quarter as much light as a subject 2 feet from the light—double the distance, decrease the light to $1/4$th strength.

If you find that part of your subject is in shadow you can fill in by using a reflector—such as a piece of crinkled household-type aluminum foil. Hold it outside the camera's view and move it about until it reflects the light on to the shadow areas you wish lightened. If you can have someone do this for you, so much the better. If not, attach the foil to something with a clothespin. Your household undoubtedly already has natural, built-in reflectors. A group seated around a dinner or party table covered with a white tablecloth will be illuminated by the room light, with fill-in illumination provided by the light reflected by the cloth. Similarly, harsh shadows can be relieved in home portraits by positioning your subject near a light wall or drape from which the light will bounce back onto the dark side of the figure.

You can also boost incandescent light by changing your present household bulbs for ones of higher wattage. Be careful, though, to avoid overloading fuses.

If you choose color film for indoor shooting

INCANDESCENT ... continued

by incandescent lighting use a film balanced for tungsten light to decrease the orangy cast caused by the lighting. If the light source is fluorescent, use daylight film. (Filtering will further enhance results in both situations.) And, if you rely on reflectors when shooting color, make sure they're white, or they'll lend their own color to your pictures.

Both the photos on this spread were made by the light of a hanging lamp. The portrait below suffered from slight camera shake during the 1/15th sec. exposure. However, both the photographer and the subject were pleased with the impressionistic result. Photo opposite by Patricia Maye. Photo below by Rafael Fraguada.

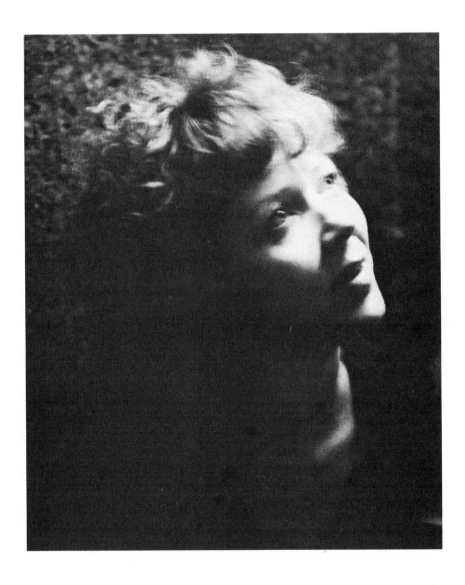

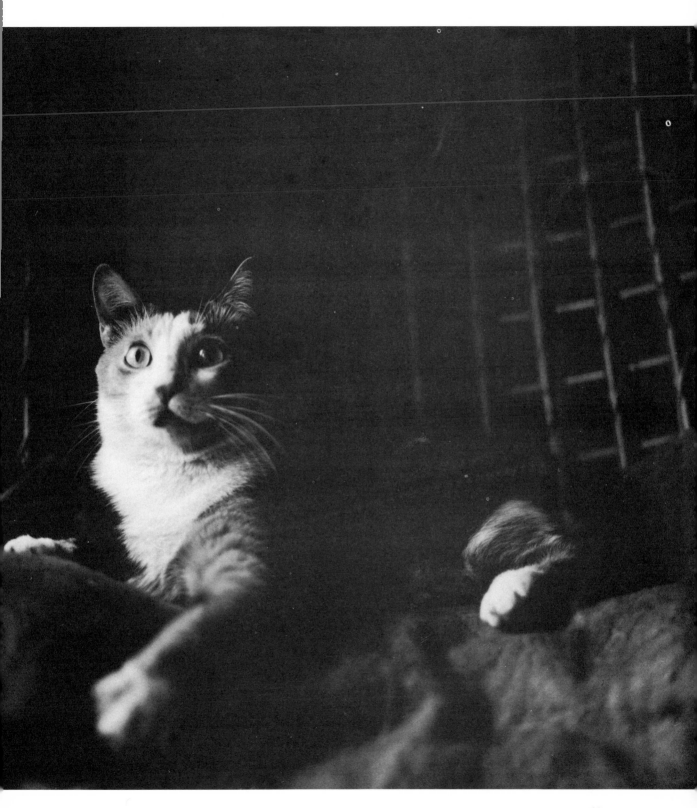

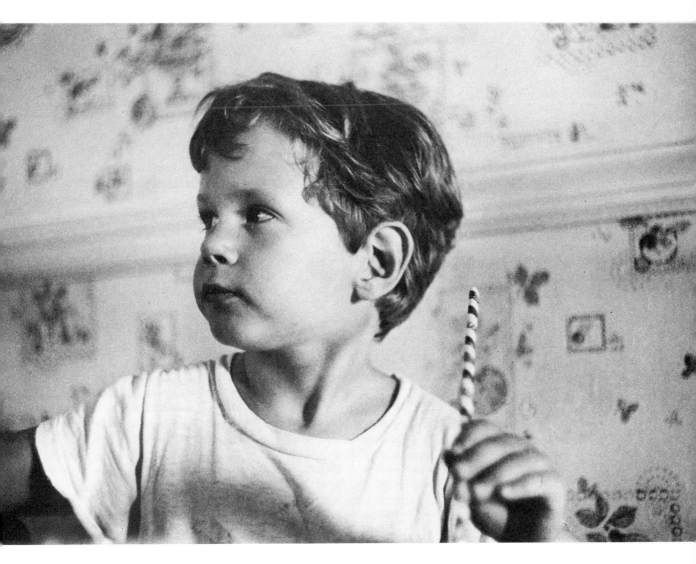

Both these informal kitchen portraits were shot by available, overhead light. Tri-X film was used with a shutter speed of ¹/₃₀th sec. at maximum aperture. Photos by Patricia Maye.

STREET LIGHT

Many times the illumination for your urban night shots out-of-doors will be from street lamps. This source will usually give sufficient light by which to capture your subject, provided the subject is placed so that the maximum amount of light from the street lamp falls upon him. Take your meter reading from the subject's face unless you want the person in silhouette.

In night scenics lit by street light, use an overall reading of the scene as a guide, pointing the meter slightly below the light source. (Stand at least 15 feet away to avoid an inflated reading.) Bracket at 2 and 4 stops lower than the prescribed reading.

These pictures often create great mood shots and it has never failed to amaze us how beautiful a street that is drab by daylight can become when captured on film at night. Under this form of lighting the dirt melts away, the ugliness disappears, and what is left is a thing of mystery and at times enchantment.

Lighting in urban street scenes is generally so mixed that it is impossible to say whether using daylight or tungsten balanced film is best for shooting color. Daylight film will produce warm, golden pictures, tungsten, cool. Try both. The choice is entirely one of personal preference.

FLASH

There will be times when you simply do not have enough available light to expose a picture by, so you will have to use flash to boost the existing light.

Flashbulbs—which are used once and thrown away, and electronic flash, a rechargeable source of high-speed light flashes which you can use many times are the two basic types of flash.

To calculate exposures, divide the flash-to-subject distance into the lamp's guide number to get the correct f/stop. (Guide numbers are to be found on flashbulb cartons, film instruction sheets, and the instructions that come with electronic flash units.) The latest electronic flash units feature light sensors that gauge existing light and automatically produce an appropriately bright flash without exposure calculations.

When flash is aimed directly at a subject the three-dimensional quality diminishes and harsh shadows are formed behind each person and underneath objects. For this reason it is generally better to use bounce flash.

Simply aim the flash unit at a light-colored wall or ceiling to act as a reflector (remember, white only if you're using color film) and you will be able to diffuse the direct glare of the flash and achieve a softer, more natural-looking picture. Exposure compensation must be made for the extra distance the light must travel in going from flash, to ceiling or wall, to subject, as well as for the diffusion along the way. In a normal-sized, light-colored room, figure the distance from flash, to reflecting surface, to subject, calculate the f/stop normally, then open up one extra stop. In an extra large or dark room increase exposure by two stops.

When using flash, remember that the light falls off rapidly the farther away it is from the subject. Therefore, remember as you change the flash-to-subject distance you will have to recalculate the f/stop.

This may become time-consuming if you're going to work at a number of ever-changing

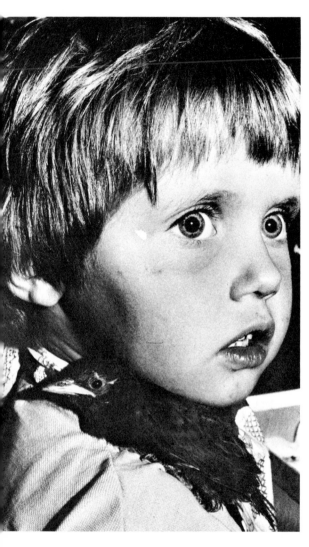

Electronic flash was used to illuminate the starling on the child's shoulder. The bird would have been a dark, undecipherable shape without the auxiliary lighting. Photo by Horst Schafer.

distances. A good idea is to determine beforehand the distances you will want to work at most often, then figure out what f/stops to use. These stops can then be written on a card and pasted on the back of your reflector. For example, you will probably find that most of your shots will be taken as head shots at about four feet, medium shots at six feet, full length shots at ten feet, and large groups or distant shots at 15 to 20 feet. Practice framing and focusing and standing opposite typical subjects at these distances.

Flashbulbs come in two types—clear and blue. Either can be used with black-and-white film. For color, use blue bulbs with daylight film. Electronic flash units are balanced to simulate natural daylight: they should be used with daylight color films.

Unwanted reflections are a common hazard in using flash. There is no prechecking possible as your light and exposure are simultaneous. Insure against ruined results by checking backgrounds for highly reflective objects such as mirrors, glass or metallic surfaces, or unshaded windows. If your portrait subject wears glasses have him look away from the camera so the light won't strike his lenses square on.

Amateur flash-lit color portraits are often cursed by a phenomenon known as "red eye", and an unhealthy looking condition it is indeed. It occurs because the subject's irises are dilated due to the relative low-light level. The flash goes off, passes right through the wide-open irises and illuminates the back of the eyeballs, which are duly included in the picture. Happily, "red eye" is easily cured. Simply have your subject look off at a slight angle and the flash won't enter his eyes. If a head-on shot is a necessity, for identification purposes for instance, have the subject look at a bright light first to stop down his irises automatically. Or, if the subject is fascinated by you and your camera, as is often the case with children and pets, remove your flash unit from its camera mount and hold it up and to one side.

EXTREME CONTRAST

Very often in available-light night photography you will run into situations in which the separation between shadow and highlight areas is so great that it will be extremely difficult to reproduce both equally well. These are situations of extreme contrast.

In order to obtain a usable photograph under such conditions you will have to decide exactly what you want in your reproduction of the scene. You can decide, for example, that either the highlight or shadow area is more important, and expose for that area alone. The result can be a very dramatic photograph. Or, you may decide that it is important to have detail in both the highlight and shadow areas. In this case you can expose for the shadows; open up one or two stops and then underdevelop to retain some gradation and detail in the highlights. By this technique you will gain a compromise between high and low tonal values though it's impossible to reproduce completely the entire range of shadow-to-light values. Such extreme ranges are beyond the film's ability.

Another way of handling extreme contrast in addition to the overexpose-underdevelop method is to use a soft-working developer, such as Microdol-X, Rodinal, or Promicrol. With these developers emulsion speed is maintained without blocking the highlights. Then print on a normal #2 paper.

When shooting color, the extremes of night lighting play an important role. Color film lacks the contrast latitude of black-and-white film, so exposure should be made for correct detail in the highlight areas. Otherwise highlights will be washed out.

A slow shutter speed was used to capture the streams of water flowing from the fountain. A tripod is necessary for such time-motion studies. The high contrast negative was printed normally on Polycontrast paper. Photo by Kathy Wersen.

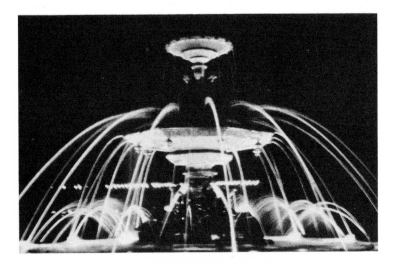

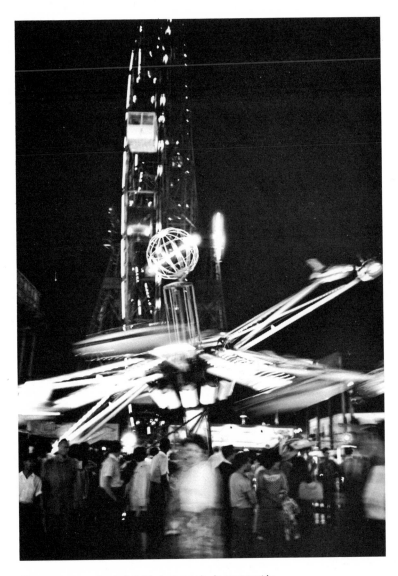

The extreme contrast of night photography is apparent in this subjective, slow-shutter shot taken at Coney Island. The bright lights twinkle against the darkness of the shadows and sky. Photo by Kathy Wersen.

4
'SCAPES

The soft landscape on the opposite page was shot just before sundown with the sun behind the photographer. At dusk, shadows are diminished allowing for full detail rendition throughout the scene. The shot was made on Tri-X film with an 80mm Zeiss Planar lens. Photo by Patricia Maye.

'SCAPES

'Scapes are among the most popular of all photographic subjects—even at night. Seascapes, landscapes, and cityscapes all offer many exciting picture subjects at night, when they appear in completely different moods than by day.

Many photographers tend to set their cameras at infinity and use a small lens opening to get depth of field—but often these pictures are unexciting and unimaginative. Why not experiment with the gamut of f/stops? And instead of attempting to capture the entire 'scape, why not spend a little time searching out an unusual angle from which to take your picture, or concentrate upon a small segment of the total scene which seems to have a special meaning to you? Then isolate it through selective focus with the background or foreground thrown out-of-focus by a large lens opening.

Long, thin vertical or horizontal 'scapes are often very exciting and will add depth to your pictures. And, 'scapes which include a foreground frame, point of interest, or people, are usually stronger.

The easiest time to take these pictures is at dusk, just after the sun has gone down. This will allow you to work at faster shutter speeds and to register more detail and separation between sky and foreground.

If the sky does not register dark enough to appear as night on your first print, burn-in this area after you have given the rest of the print the proper amount of exposure.

SEASCAPES

The romance and mystery of the sea has captured man's imagination for centuries. Here is one of the most exciting areas of scenic photography, for the seas, rivers, and other large bodies of water reflect a myriad of moods—and are as changeable as a woman. Sunsets, twilight, night and pseudo-night shots perhaps best reflect to the viewer the mystery of the sea.

Water acts as a strong reflector. Thus there are many unusual patterns of light to be caught at any hour, from reflections, to moonlight (see page 40), to dancing sunlight underexposed to create the unusual night effect seen on the opposite page in Horst Schafer's river scene.

Exposures made with apertures from f/11 to f/22 tend to change bright light reflections on water into diamond and other unusually shaped patterns as you see in the accompanying illustration. For more information on pseudo-night shots such as this one, refer to Chapter 8.

True night shots of the sea are best undertaken under a full moon. The time exposures necessary make a tripod or other firm camera support a must. The motion of the waves can be used to lend a note of liveliness if you include some static element such as rocks, driftwood, or shoreline in the foreground.

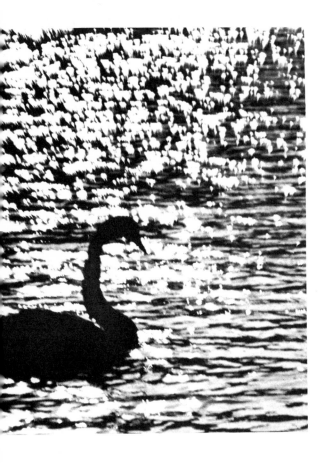

This waterscape with swan looks as if it was taken by moonlight. In truth, it was taken on a bright sunny day. Exposure was made for the highlights on the water, letting the swan become a dark floating silhouette. Photo by Horst Schafer.

Like the shot above, this riverscape was, in fact, taken in bright sun. The negative was deliberately underexposed, then printed on high contrast paper. Photo by Horst Schafer.

LANDSCAPES

Perhaps the most important element in landscape photography is design, for without a good sense of design the most unusual and beautiful of landscapes will be boring when ineptly captured on film. You cannot, of course, rearrange your subject matter when dealing with 'scapes—but you can interpret nature in your own way through your choice of angle of view, lens, lighting, or film choice and method of printing.

Just as the artist uses the techniques available to him to give his own interpretations of a scene, so the creative photographer can use the techniques available to him to record nature as he "sees" it.

Different weather conditions, such as rain, snow, fog and mist, will help you to capture unusual moods in landscapes. To strengthen your creative eye, choose a landscape near where you live and photograph it over a period of time under these many varying conditions. This will help you to know what to look for in future situations.

Night and pseudo-night photographs of necessity sacrifice the fine detail and texture that can hold interest in your daytime landscapes. Try to pick out interesting masses and shapes to include in your composition. The eerie silhouette of a single tree against the moon and sky, a bare foreground branch with the moon behind it out of focus, will maintain interest by their strong design.

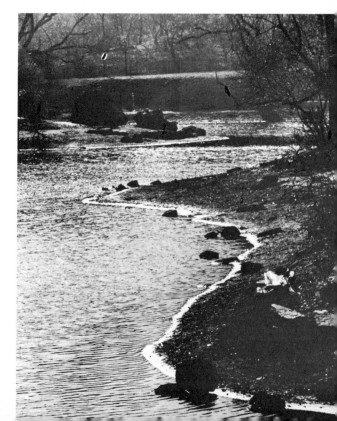

This landscape was shot in Central Park just before sunset. By making a normal exposure, plus one that is one stop underexposed, and another that is two stops underexposed, you can produce negatives for a sunset, twilight, and night effect in one shooting. Photo by Horst Schafer.

54

CITYSCAPES

A third exciting subject is the cityscape, as revealed in its patterns and design. This subject never seems to lose its power over photographers. In fact, if one could venture a guess as to which night subject has been photographed more than any other, it would no doubt prove to be the city.

The magic seems to lie in the fact that each city has its own personality—and this personality seems to exert itself most at night. Trying to capture this personality on film represents a challenge to the photographer, much like getting to know an interesting new person.

Do you know your city or town? If you are venturing into night photography for the first time, why not give yourself the assignment of documenting your town by night over a period of time. Capture its many moods through scenics from sunset to dawn—and from many angles. Then capture the townspeople in relation to their city: what they do, where they go, etc. You may come up with an unusual picture story for your local paper. But more important, you will certainly learn how to photograph by night!

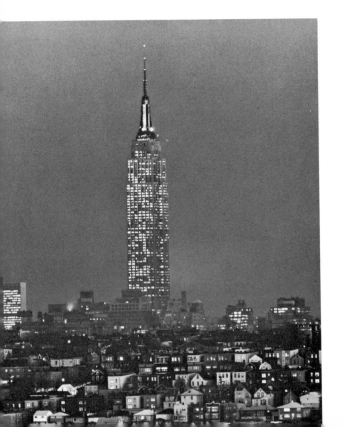

This shot of Manhattan, dominated by the Empire State Building, was made from over five miles away in New Jersey. The winter months are usually best for such long distance shots, as the atmosphere is generally clearer in winter to permit better long range recording. Photo by Gerald Healy, Photo Trends, Inc.

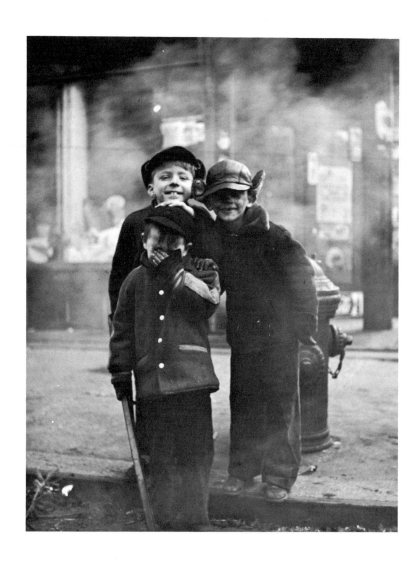

These cheerful models interrupted their post-holiday task of burning a Christmas tree to pose for the photographer. Holiday times are rich with opportunity for the photographer willing to stroll around town with his camera. Photo by Gerald Healy, courtesy Popular Photography Magazine.

5

PICTURES AROUND TOWN AT NIGHT

PICTURES AROUND TOWN AT NIGHT

No matter where you may be in your evening hours, there will probably be many exciting nighttime subjects available to you—if you keep an eye open for them. Pictures on the street, such as the photograph on page 39 of the dancing steam, and on page 56 of the young boys, taken in the Chelsea section of New York City, or on page 63, taken in Rockefeller Center, are examples of the kinds of moments you can capture around town at night.

Also look for interesting houses (page 58), buildings (page 55), and bridges (page 59). And light patterns of all kinds. (See Chapter 8.)

Why not try carrying your camera about with you some evening? You may be rewarded by many exciting shots. Even scenes which seem dull and uninteresting during daylight hours take on a new air and mood after the sun has set. In fact, if you'd like to try an interesting experiment, why not duplicate some of your daylight shots at night and compare the two?

Your home or office building might well prove much more photogenic after dark. This shot took a five-minute exposure at f/22. Photo by Gerald Healy, Photo Trends, Inc.

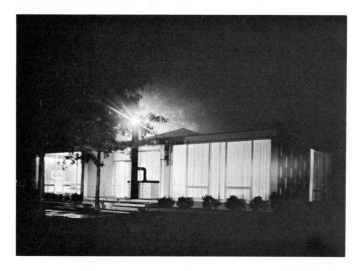

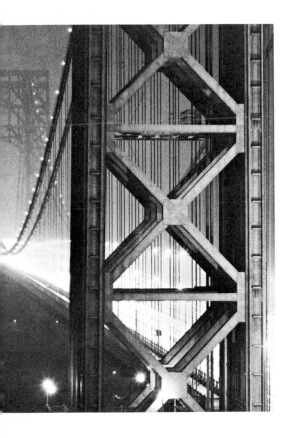

The angle of view makes this picture come alive. A misty night provided the atmosphere. At f/22, even a five-minute exposure resulted in underexposure. Increased processing time made up for the deficiency. Photo by Gerald Healy, Photo Trends, Inc.

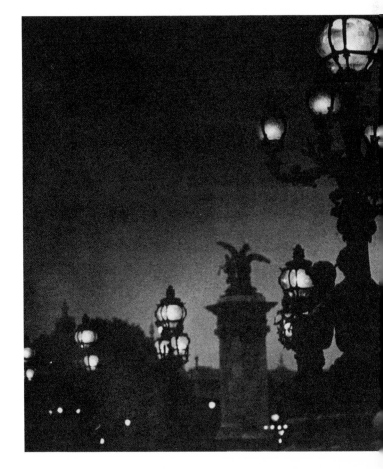

The romantic charm of the lamps along a Parisian bridge attracted the photographer. A setting of f/16, for maximum definition in depth, necessitated a 2 sec. exposure. Photo by Richard Statile, Photo Trends, Inc.

59

SHOP WINDOWS

Daytime photography of shop-window displays is complicated by the glare of reflections off the glass and passing pedestrians and window shoppers unconcernedly blocking your view. After dark, the reflections are less general—you need only be alert to the danger of a passing headlight, streetlamp, or your own flash appearing in the picture—and passersby are few.

Black-and-white films can be used, but color will yield results with the full range of beauty and interest conceived by the window designer. A wide-angle lens will allow you to approach the subject closely and take it all in without having to step off the curb. Remember, even reduced traffic is a hazard. A tripod will be a great asset in careful framing and squaring up your picture. Set up at a distance sufficient to take in the whole window, and then level the camera so that the film and the window are as parallel as possible. Use your viewfinder to check for composition and reflections. Meter from that portion of the display you wish to emphasize. Then shoot—using a cable release or bulb for time exposures.

If you wish to include window shoppers, real or posed, you can shoot either square on including them as back-lit, framing silhouettes, or from a side angle to include their faces lit by the illumination from the display. Introducing live models will, of course, shorten your practical exposure time. Interesting results can be achieved, if somewhat chancily, by choosing your smallest-aperture–longest-shutter-time combination to record the static window display in perfect detail and the real pedestrians and shoppers as ghostly, blurred images.

The photographer spotted the handsome mannequin opposite on the way home after a day of shooting. He took the time for one last shot. The $1/30$th sec. exposure was made by the illumination in the window display on Tri-X film. Photo by Rafael Fraguada.

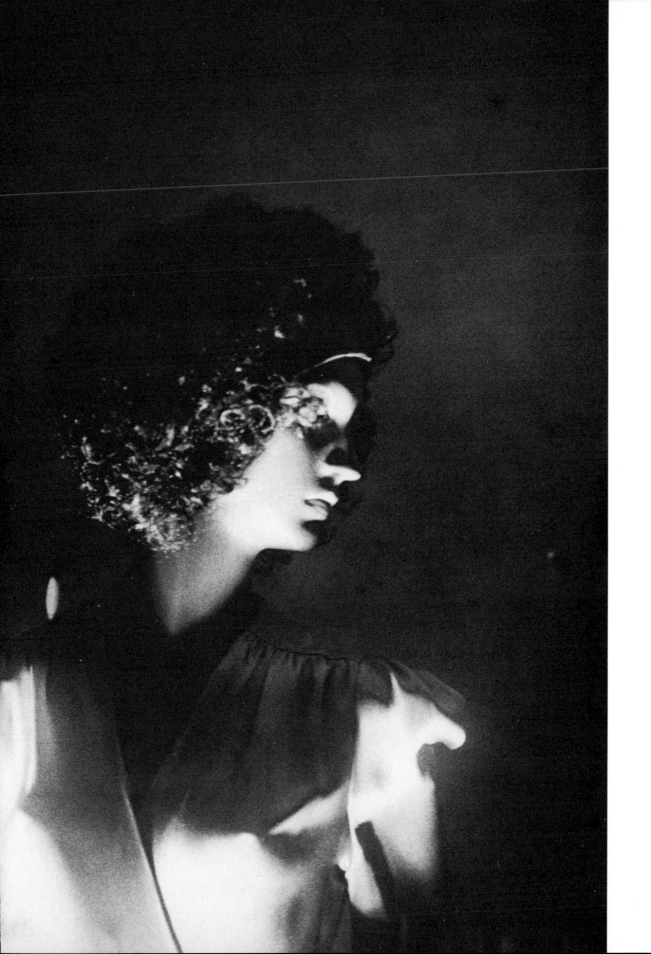

FLOODLIT LANDMARKS

Many cities floodlight their most famous landmarks, buildings, and monuments at night. These prove to be ideal subjects for your night photography and there is no reason to settle for a standard, commercial picture postcard to document your travels when you can quite easily take a personal souvenir of your own.

Unless you are privileged to own a view camera—the architectural photographer's standard tool—with its perspective correcting adjustments, you should choose a distant enough viewpoint to avoid severe, upward camera tilt and resulting distortion. For natural-looking results, plus a large image size, shoot from a distance and use a moderate telephoto lens or crop in on your normal lens negative when printing. But, bear in mind that a violently foreshortened close-up view of a familiar landmark may well turn an overworked subject into a dramatic photograph. In photography, as in all things creative, the rules of normal rendition are made to be broken.

When shooting a building, study it from a variety of viewpoints. The main façade will doubtlessly be well-lit and easily photographed. But, shot head-on the building may well appear very flat and lack detail. If you shoot from a corner angle you'll achieve dimension by including both the bright façade and a less well illuminated side. You'll also pick up some shadow detail on any façade embellishment.

Time exposures are no problem with static landmark shots. And, a small aperture combined with a long exposure will convert the headlights of any passing traffic into bright ribbons of light.

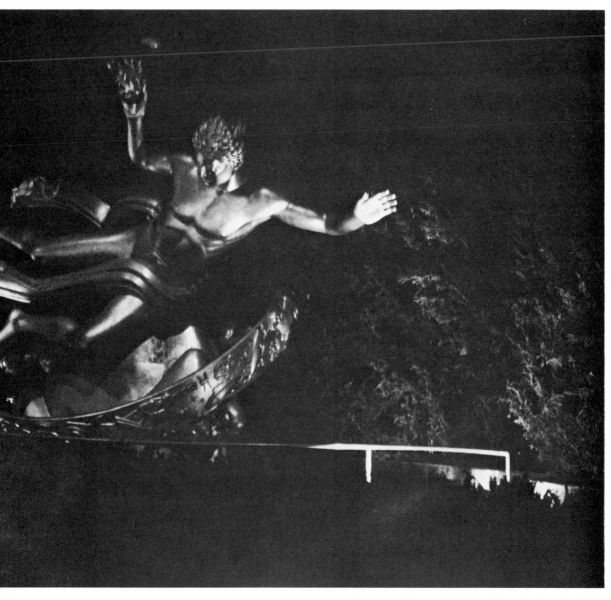

Prometheus floats nightly above the darkened skating rink at New York's Rockefeller Center. Display spotlights provided the illumination for this shot made on Tri-X, rated at ASA 1000. Photo by Rafael Fraguada.

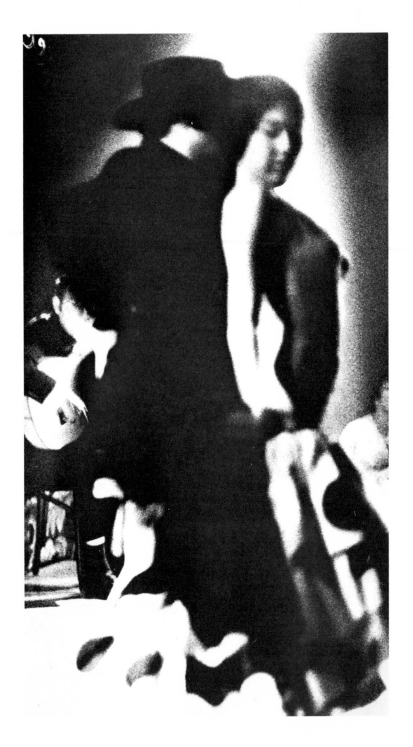

An evening on the town is a natural picture-taking opportunity. A 35mm camera is small enough to be carried without inconvenience and you may come back with a souvenir like the dancers shown above. Photo by Kathy Wersen.

6

ENTERTAINMENT

ENTERTAINMENT

Nighttime entertainment provides a whole new stimulating world for the photographer, which is usually unavailable to him during the day: theaters, concerts, nightclubs, sports events, and special subjects such as ice shows and the circus. At many of these events you can photograph without permission, and at others, permission is generally attainable at specific times or under specific conditions. For example, the management of a theater may not allow you to photograph from the stage, but may be perfectly willing for you to photograph from the audience, provided, of course, you do not distract the audience or the actors. The best rule of thumb to use is to ask permission.

Lighting is generally very contrasty in the entertainment world and will require compensating soft-working developers if you want to equalize the tonal range. However, you may like the dramatic effect of this contrasty lighting. If you have no favorite film-developer combination, we would like to suggest our own —Tri-X rated at 1200 ASA and developed in Acufine. This we have found to be the highest speed-finest grain combination. For really low-light levels, use Tri-X rated at 2400 ASA and developed in Diafine. This should practically take care of every shooting situation you will encounter in the world of entertainment. (See also Chapter 1.)

For color shots, Kodak's High Speed Ektachrome (ASA 150) or GAF's 200 or 500 Color Slide films will allow for shooting under most performance circumstances. Remember that special processing allows you to increase High Speed Ektachrome to a rating of ASA 400 and GAF 500, to ASA 1000. Confessedly, both films become grainy in push-processing but grain in color theatrical photography can become a dramatic pictorial asset.

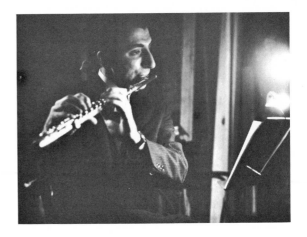

A small lamp on the music stand provided the only illumination for this shot of a musician in the pit. A 50mm lens was used for a 1/15th sec. exposure at f/1.4. A rangefinder camera, less noisy than an SLR, was used. Photo by Kathy Wersen.

MUSIC AND DANCE

For the person with a creative eye there are many interpretations possible when photographing music and dance, be it professional, amateur, or school groups. Take, for example, the two pictures on pages 68-69, which show completely different approaches to two saxophone players, or the two dance shots on page 70, the one stressing a contrasty grainy effect with slight movement and the other freezing action with a finer grain pattern.

Photographs of music and dance can be pictures of rhythm when the photograph conveys sound, motion, and the drama of a rhythmic moment. Your clever use of stage lighting with its bright spots and dark shadows along with a selective angle of view can also help to create this. Look at the picture of the pianist on page 67. The angle of view was changed to that of looking out at the audience and the pianist's head was utilized to block out the spot facing the camera for a rim light effect. Then a short exposure was chosen to purposely underexpose the shadow areas for this silhouette effect. All of these choices help to communicate the feeling of aloneness, for the pianist, isolated from his audience by the stage, is involved in his own world of music.

The cadmium sulfide meters which measure a narrow angle of view are the best meters to use for these photographic situations, particularly when you can't get close to a stage and must take a reading from far away. The three spot meters available with the narrowest angles of view are the Honeywell 1°/21°, Soligor Spot Sensor, and the Minolta Auto-Spot 1° which read a 1° angle. There are also two CdS meters at 18° and one at 10° listed in Chapter 1, page 23. Since the narrower angle of view measures a smaller part of the distant scene, these meters give a much more accurate exposure from afar than any other kind. The wider meters require the additional exposure of one to three stops since the farther away they are, the larger the area of the scene they read, thus exaggerating the highlights and inflating the reading.

Stage light was sufficient for an exposure of f/5.6 at ¹/₁₂₅th sec. on Tri-X overrated at ASA 1200. Photo by Kathy Wersen.

A backstage view produced a silhouette shot of the pianist. Underexposure in the shadow areas was deliberate to heighten the effect. Tri-X was rated at 1200 ASA for an exposure of f/2.8 at ¹/₆₀th sec. Photo by Kathy Wersen.

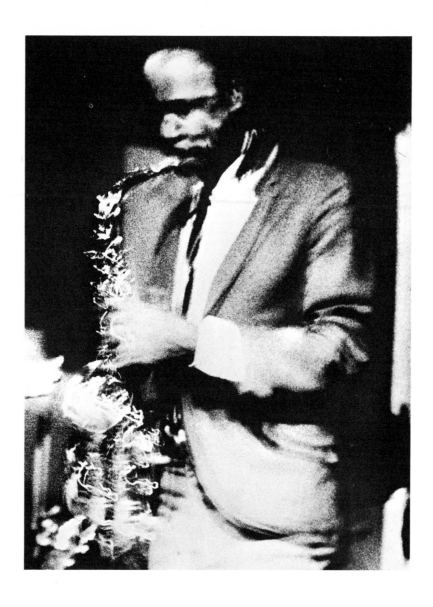

An exposure time of ¹/₄th second produced this motion study of a saxophone player. The movement is especially evident in the musician's hands, head, and instrument while his relatively immobile torso is rendered quite clearly. The interplay between movement and stability heightens the shot's effect. Photo by Kathy Wersen.

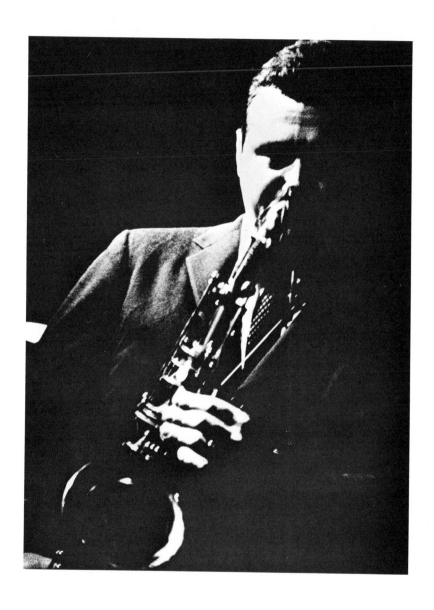

This high contrast portrait of saxophonist Stan Getz was made by the light of one spotlight to the side of the subject. The negative had more detail than is evident in the print used for this reproduction. The print was deliberately made on high contrast paper. Photo by Kathy Wersen.

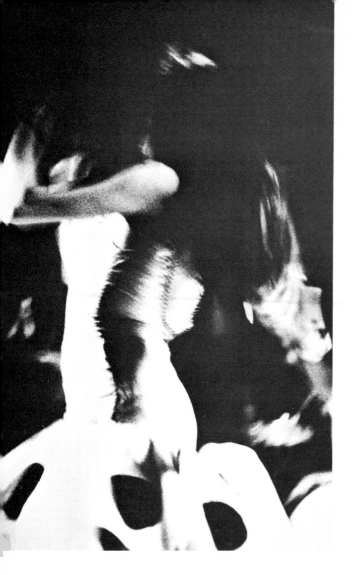

These two photos display two approaches to the same subject. The shot at left deliberately emphasizes the dancer's motion. The shot below, taken at a faster shutter speed, catches the facial expression and freezes the dancer and her partner in their embrace. Photos by Kathy Wersen.

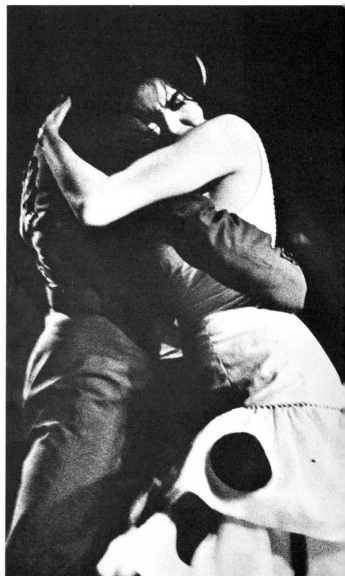

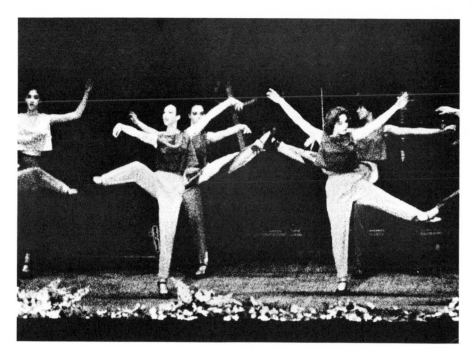

A Philadelphia high school group served as subjects in this dance performance shot. Grain in the print was emphasized by enlarging a small section of the negative. Photo by Kathy Wersen.

A stage-level view heightens the drama and sense of movement in this shot. If it is possible, remember to take a shot or two from a different viewpoint to increase the scope of your coverage of any subject. Photo by Kathy Wersen.

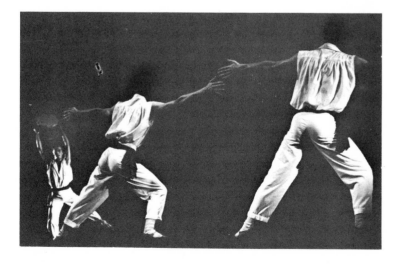

SPORTS

There are many, many night sporting events, both indoors and out, available to the photographer: baseball, trotting races, basketball games, boxing matches, ad infinitum.

Here are three basic techniques by which you can capture exciting action shots—blur, panning, and peak of action.

By using a shutter speed slower than you would need to catch the action sharply, you can use the technique of blur to give a feeling of the motion of the original scene. Horst Schafer's bike race on page 73 is a good example of this technique. Slower shutter speeds can also be used to capture varying degrees of blur.

Panning refers to the technique of moving the camera while shooting parallel to the action. This can stop the action but blurs the background and gives an extra emphasis to the feeling of motion of the subject. Panning takes practice. Wait for the subject to enter your viewfinder. Then hold it in place in the viewer by moving the camera in unison with the subject while you make your exposure.

Peak of action shots are snapped at that second in which the action is frozen for an instant at the peak of its performance, before it begins its descent. A pole vaulter, high jumper, basketball player, or leaping figure skater can all be stopped, even at seemingly slow shutter speeds once you master the technique of peak-action shooting.

By using these three techniques you can interpret as well as record the world of sports.

Direction of travel is another important consideration in shooting sports. Action that moves across your field of vision, parallel to you and your camera, requires higher shutter speed to stop it than action that is coming toward or moving away from you. If you can position yourself at the curve of a race course to photograph the race as it comes toward you, or under the basket at a basketball game to capture the players as they head down the court, you'll have more success than attempting to stop the motion as it goes by.

When it is possible, take your light readings in advance from the areas you will photograph. In low-light levels, note the areas of greatest brightness and take readings. If you then wait for the action to come into these spots, you will be more certain of getting good pictures

It is also a good idea to pre-focus upon a specific point and wait for the action to move to your target point. You'll be guaranteed regular action if you prefocus on the goal, home plate, or finish line. Your seat location can aid you in getting dramatic sports shots—the closer, the better. The extra expense for good tickets will be quickly forgotten when you view your results. Don't ignore side-line and audience shots at sporting events; often the action on the bench or in the stands is more dramatic than the contest itself.

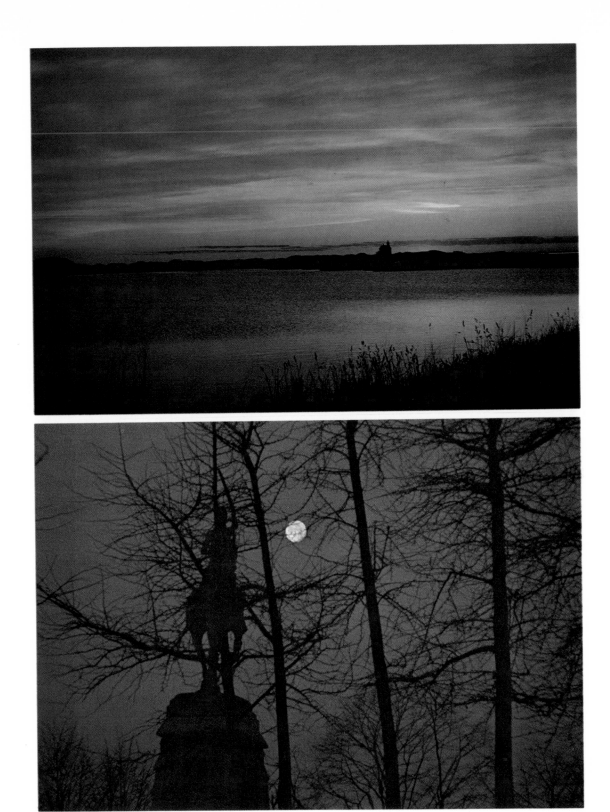

(preceding page) A suburban bay and a city park were the shooting sites for the sunset and moonlit pictures. The sunset was shot on Kodachrome film at a shutter speed of 1/15th sec. Despite the full moon in the photo of the sculpture in the park, the picture was shot at dawn. The sun was rising in the east, but the photographer shot west into the darkness and captured a night effect. Both photos were taken with a normal lens. Photos by Patricia Maye.

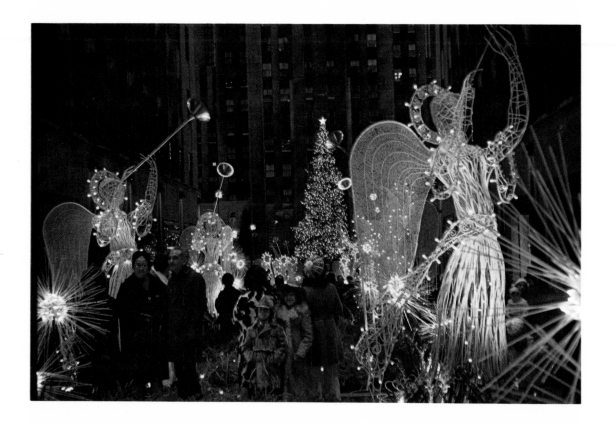

Holidays and city festivals provide the urban photographer with varied, year-round, picture-taking possibilities. Wire sculptures, brightly lit with twinkling bulbs, were part of the Christmas decorations in New York's Rockefeller Center. High-Speed Ektachrome Film was used to keep exposure times to a hand-held speed. The golden figure opposite represents San Gennaro, patron saint of Naples. The statue is the focal point of the annual celebration in honor of the saint in New York's Little Italy section. GAF 500 Color Slide Film was used for the exposure. Photo above by John C. Wolf. Photo opposite by Rafael Fraguada.

After-dark vacation pictures can be among your most exciting shots. The photo above is of the exterior of the casino in Freeport. The exposure was made on Ektachrome (tungsten) Film which gave naturalistic color rendition of the floodlit building. The shot below started out as a simple skyline shot of the city of San Diego across the bay. The photographer remains mystified by the dazzling light tracing in the foreground but suggests that a brightly lit boat may have passed during his time exposure. A second possible explanation is that a second exposure was accidentally made over the skyline. Whatever the contributing factors, they combined to create a successful abstract. Photos by Seymour D. Uslan.

An exposure time of $^1/_{1000}$th sec. was necessary to freeze the motion of the speeding bike racers. Fast films, large aperture lenses and the bright lighting in modern sports arenas make such shots possible. All extraneous detail was eliminated from this print by underprinting on high contrast paper. Photo by Horst Schafer.

The wide angle of view and dominance of the lead runner emphasize the pressure of the race. A 30mm lens was used to include both the lead runner and his pursuer. Photo by Horst Schafer.

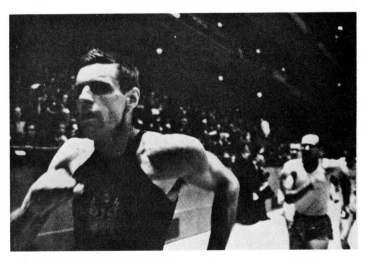

CIRCUS

Children never grow up when it comes to the circus. Whether you are 6 or 60 the sights, sounds, and smells cannot help but evoke the emotion of excitement—and nostalgia for the adults. The animals, clowns, aerialists, band, and jugglers will give you a multitude of scenes to photograph. And you can do so from your seat with ease. Or, if you prefer, you can usually get permission to photograph from ringside, and perhaps even from inside the ring.

Your best bet will be to use high-speed film so that you can shoot fast shutter speeds when you want to freeze action. The special techniques of shooting sports—blur, panning, peak action, and prefocusing can serve you equally well at the circus. The excitement of the circus parade might be enhanced by a blur shot. Panning with an equestrian performer or trapeze artist will increase the sense of speed and daring. And, peak action, the instant of hesitation at the top of a trapeze swing, is the moment at which dangerous leaps and catches are made and at which you can most easily snap your picture. Or, prefocus on the appropriate entrance to the ring and you can capture the star as he steps dramatically out of the shadows into the spotlight.

From a grandstand seat, a medium to long telephoto lens will pull the performers in closer to you and help you to narrow your field of interest. Try to take reflected meter readings at the edge of the ring before the show begins. A starting point for circus exposures encompassing light variation with Tri-X rated at 1200 ASA would run from f/2 at 1/60th to f/8 at 1/60th, a four-stop variation.

The fantasy world of the circus lends itself especially well to special effects. Check the advertising pages in your favorite photo magazine for special attachments for multiple images, screens to produce star-like diffraction, colored filters, tele-extenders, and zoom attachments. Your imagination is your only limit.

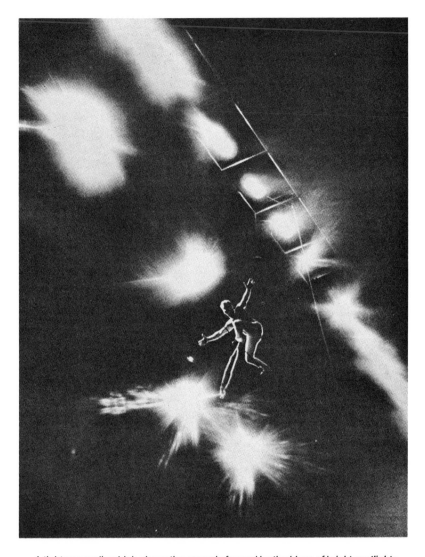

A tightrope walker high above the arena is framed by the blaze of bright spotlights. The photographer diffused the light from the spots by holding a piece of glass, selectively smeared with Vaseline, in front of the lens. A small clear section in the center of the glass allowed the image of the tightrope walker to pass through clearly. Because the shot was made with an SLR the effect could be viewed by the photographer as she shot. Photo by Jay Hoops, Photo Trends, Inc.

The internationally celebrated clown Popov and his
assistant were photographed at a performance of the
Moscow circus as they made a caricature of a member of
the audience. The photographer could have approached
more closely for a tighter shot but he was attracted by, and
wished to include, the shadows of the two men created by
the cross lighting. The 1/60th sec. exposure was made on
Tri-X rated at 1200 ASA. Photo by Rafael Fraguada.

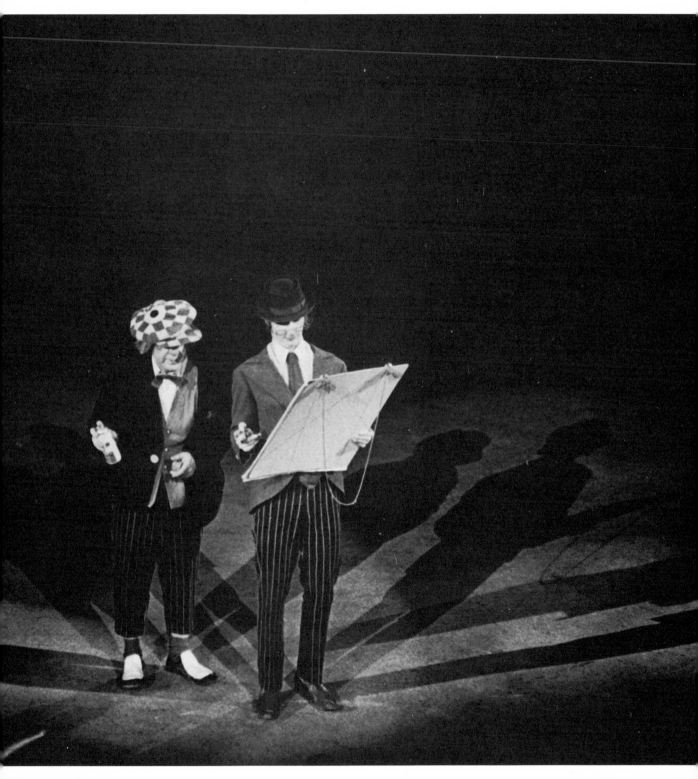

THEATER AND TV STUDIOS

Just as in the case of circuses, it is possible to get good theater pictures from your seat in the audience. Your limitation, of course, will be the inability to move about to vary the angle of view.

Stage lighting runs the gamut from high to low and from contrasty to soft diffused tones. If you can take readings from the front of the stage ahead of time, do so; otherwise a CdS spot meter will give you the most accurate readings from your seat. However, you will still have to do some guessing. If the star is standing in a strong spotlight and a microphone in front casts a deep shadow across the body, don't waste your film. The results will look terrible—particularly in color!

Figuring you are about 20 feet from the stage action, you can shoot Tri-X or High Speed Ektachrome at 400 ASA from $f/2-f/8$ at 1/60th. A performer in a spotlight with medium to full stage lighting would be captured at about $f/8$ at 1/60th. The farther away from the stage you are, the more you will have to open up the lens aperture.

Unlike that in most performance situations, the lighting in TV studios is designed for photography. The lights are balanced to 3200 K for the color television cameras and will provide perfect color rendition on tungsten color films. Individual entertainers can be photographed with a long lens from your seat without any flash. A wide-angle lens will allow you to take in the whole scene—lights, cameras, technicians, and even some of the audience—to show how different the disorganized beehive of production activity is from the orderly cropped version of the proceedings that appears on the home TV screen. As always, a spot meter will serve you well. But, if a general reading is the best you can get, remember that bright spotlights may give you a false reading. So, insure results by bracketing.

The drama of Arthur Miller's "A View From the Bridge" was photographed from the audience with a rangefinder camera. The quiet rangefinder is the best camera to use if you wish not to disturb other members of the audience or the performers. Photo by Kathy Wersen.

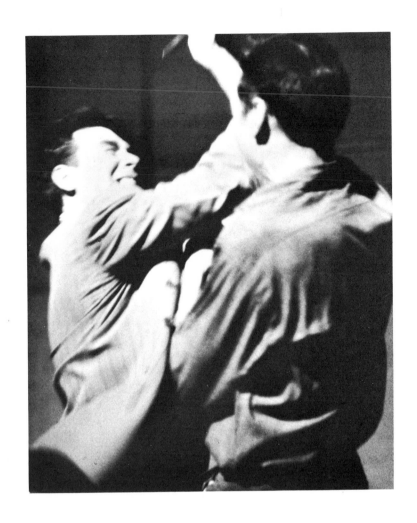

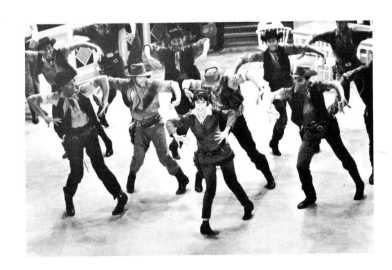

Popular entertainer Carol Burnett leads the dancers on her TV program. The shot was made from the audience with an 85mm lens. Photo by Alice Reed.

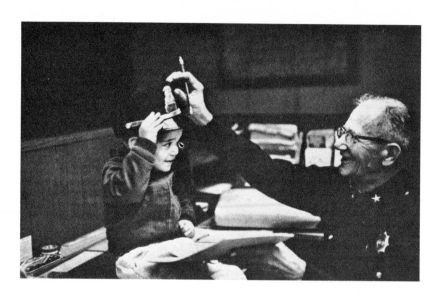

These two shots, taken by available light, indicate the range of possibilities for an after-dark photographer. The shot above was taken on the little boy's long promised visit to the local precinct. The shot below was a spontaneous one. The photographer came upon the snowball fight one winter night. Photo above by Lester Kaplan. Photo below by Herb Breuer.

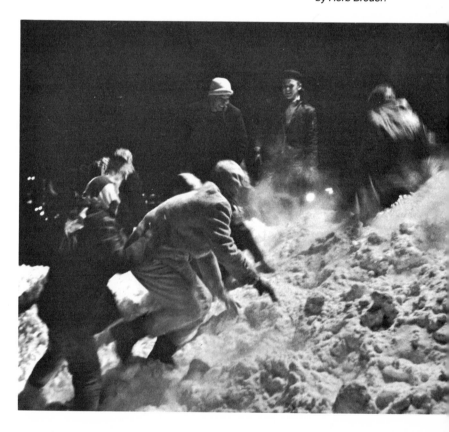

7

PEOPLE BY NIGHT

PEOPLE BY NIGHT

With the exception of weekends and holidays, the hours after 5 P.M. are the only ones most families have together. This is, therefore, a particularly good time for group shots—at the dinner table, playing games, father reading a bedtime story to the youngsters, or baby brother at the piano (page 83). Following grandma to choir rehearsal (page 83) provided an unusual portrait away from home. Or, take a typical situation. Les Kaplan had long promised his son a visit to the local police station, for the boy was fascinated by policemen and their caps. An early evening visit provided a series of prize shots, including one that was later published.

And don't neglect the world of the night people who earn their wages after the sun blinks—in hospitals, restaurants and clubs, newspapers, industrial plants, policemen on the beat, and, of course, the entertainment world which springs to life at night. Most of the subjects can be photographed easily by existing light, using Tri-X at one of its three ratings and the guidance of a good low-light CdS meter. If there is a distracting background, shoot at a wide-open f/stop to throw it out-of-focus. Background lights treated this way will create unusual design effects around your subject. Since depth of field, from any given subject-camera distance, varies with the size of the lens opening, the wider the aperture the shallower the area in sharp focus will be. Background distortion also can be controlled by moving the foreground subject farther from the background. After you have set your f/stop-shutter speed combination and focused, check the camera's footage scale to be sure the background is behind the field of focus. Look at the f/stop you are using on either side of the scale. This will tell you how many feet are in focus.

Look at the various places you go at night with an eye toward future picture possibilities—or, carry your camera with you and take them on the spot.

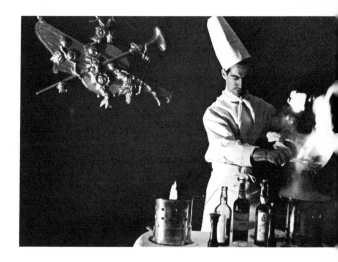

The photographer relied on an auxiliary light unit to boost the level of available light for this shot of a busy chef in the Madrid Hilton. Bracketing exposures insured results. Photo by Jay Hoops, Photo Trends, Inc.

All family members have activities that are uniquely theirs.
This portrait was made when the grandmother attended a
choir practice. Such shots are invariably more personal
and natural than any posed portrait could be. Photo by
Kathy Wersen.

Children involved in something that interests them make
ideal subjects for sequence shooting. Some toy or prop (in
this case the piano) will distract the subject from the
camera and photographer. Photo by Kathy Wersen.

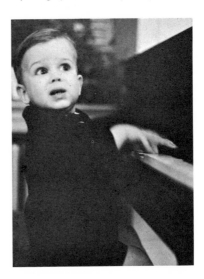

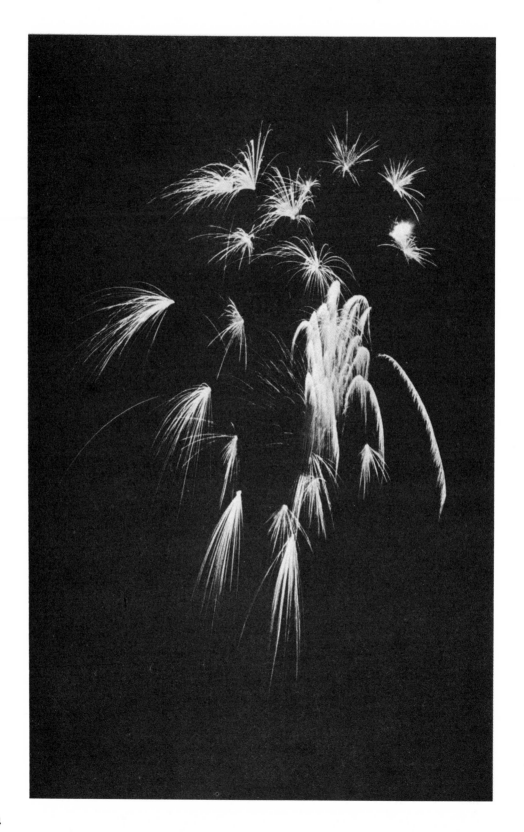

SPECIAL NIGHT SUBJECTS

A time exposure of approximately 15 seconds captured the paths of light from a fireworks display. The tripod-mounted camera set on "bulb" was triggered as the burst went off and the shutter held open until the burst was dissipated. Photo by Herb Breuer.

SPECIAL NIGHT SUBJECTS

Night presents its own unique subjects, which lend themselves to impressionistic as well as objective interpretations. Fireworks, light patterns, the moon and stars all offer the photographer refreshing new visual stimuli to record. Most of these subjects will require a tripod and time exposures. Double exposure is often used for special creative effects. Nature at night will help train you to see the full tonal range from black to white.

STAR TRAILS

Star trails are nature's way of painting with light. These pictures are more interesting when you have a foreground point of interest such as a landscape, building, or even a window frame. Healy's unusual cropping (page 86) is most effective. This type of subject matter requires the longest of exposures. The final results are always a surprise. As a starting point, use Tri-X 400 ASA with the lens stopped down to f/16 for 30 minutes. Then expose another frame for 45 minutes and another for one hour. There is no purpose in rating Tri-X any faster because the shorter exposures wouldn't allow enough time to register star movement.

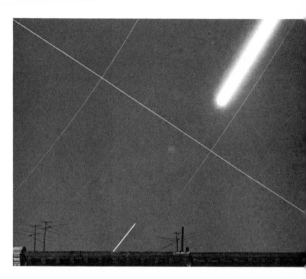

Star trails were traced on the film during a 40-minute time exposure. The bright streak from the upper left corner is the track of the moon. The light lines moving diagonally down and across the shot are the star trails. The brighter line running diagonally across the shot from the lower left to upper right remains a mystery to the photographer. Photo by Gerald Healy, Photo Trends, Inc.

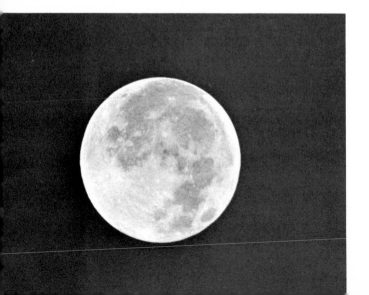

A full moon photographed through a 1000mm lens at ¹/₅₀₀th sec. produced this shot. Exposures of the moon itself can run quite short. But, the moon is a poor light source. Exposures of landscapes by moonlight must run upward from 1 second if there is to be any detail in the landscape. Photo by Gerald Healy, Photo Trends, Inc.

MOON

The moon revolves around the earth in $27\frac{1}{3}$ days and goes through four phases—from a slender crescent shape, to half moon, to gibbous phase or $\frac{3}{4}$ size, to full moon, when it is at its brightest. Most people tend to underestimate the intensity of the moon's light and consequently they overexpose. Also, in using very slow shutter speeds, they capture a blurred image. This satellite, more than a quarter million miles away, is a sunlit object reflecting about 7% of the sun's light that falls upon it. Thus, exposures of the moon itself are similar to those used for bright daylight scenes.

As a starting point for exposures, use Tri-X at its normal 400 ASA rating. For a full moon expose at f/8 for $\frac{1}{2}$ second, then 2 stops over for f/8 at 2 seconds, then 2, 4 and 8 stops under (f/8 at $\frac{1}{8}$th, 1/30th and 1/500th). Moonlight is extremely variable in its brightness range, from very dark to almost white. You'll also find a hazy night will require a diaphragm stop larger or one shutter speed slower compensation, while altitudes 7,000 feet and above require an exposure decrease of about one stop.

Dramatic and striking pictures can be made with standard equipment, particularly at the large gibbous and full moon phases. If you are fortunate enough to own a camera which takes interchangeable lenses, and have a telephoto lens, then larger size images of the moon can be made on film. Moon size can also be increased by making large blowups from a small section of the negative. Other possibilities include the use of double exposure. Place camera on a tripod and with a normal lens photograph the foreground, giving more exposure to render detail. Include a tree or building as a reference point. Then, without jiggling the camera, carefully change over to a telephoto lens and make a second exposure for a large-size moon. A single- or twin-lens reflex viewing system would be the easiest to work with here.

FIREWORKS

Firework displays, most often thought of in terms of color, can be just as exciting in black and white. Great variety can be achieved by recording one, two, or even three bursts on one frame of film. With the camera on a tripod, set the shutter release on "bulb" for one rocket burst and on "time" for longer exposures. If you want to record only sky and fireworks, hold something like black cardboard in front of the lens in between bursts when recording more than one on the time setting. However, you may also want to record foreground such as scenery or people watching. This requires additional exposure between the bursts according to how dark or light the area is. These exposures are usually arrived at by guesswork and experience. The fireworks themselves are not too critical. For Plus-X at 200 ASA, start with an f/8 opening on time. For Tri-X at 400 ASA use f/11 and so on. Try exposing one, then two bursts per frame at this setting. Then bracket under and over. This will give you a frame of reference for future shooting. For color, High Speed Ektachrome or GAF 200 Color Slide Film will record a single burst at a setting of f/4 at 1/30th. Settings of f/11 or 16 used in conjunction with a time exposure will allow you to record multiple bursts on a single frame.

By panning the camera from side to side, or up and down one or more times, or by jiggling it when the burst goes off you can create many abstract effects. One photographer we know ended up with a series of patterns that looked like musical notes when he jiggled the camera as the fireworks went off. Also, you might experiment with telephoto lenses of different focal lengths for more interesting full frame effects.

LIGHT AND LIGHT PATTERNS

Moving and stationary lights give a special mood to the night. Photographer Horst Schafer calls them the jewels of the city—and in effect they are, for like a woman the city bedecks herself in her finest to meet the romance of the evening hours.

A time exposure of moving lights will register as a light streak and paint its way across the film in many interesting patterns. To liven up your night scenics, include a street with the lights of moving cars. For variation, shoot first in a standing position, crouching to the level of the car lights, and then from a higher point of view.

The moving water of public fountains is an example of another form of moving lights. By exposing at a medium or slow shutter speed the main subject will be recognizable but the bright water within the picture will create semi-abstract patterns.

Or, you may move the lights yourself for a more abstract approach. Make an exposure of a scene including lights to establish the basic forms. Then move the camera while the lens is still open (on time). Another way to do this is to move the camera throughout the entire exposure. There is no real control in "painting with lights." We can only control the amount of light reaching the film.

A filter-like attachment called a diffusion screen will produce soft halos around bright light sources in your picture. A diffraction grating, window screen, or piece of stretched nylon stocking held in front of the camera during exposure will create a star pattern around lights. With the addition of more layers, the star effect is increased four points for each layer. If you use more than one, increase the original exposure by $^{1}/_{3}$rd for each additional layer.

Other effects you may wish to try are explained under the following illustrations. Amusement parks or fairgrounds are extremely good locations for experimenting with light patterns.

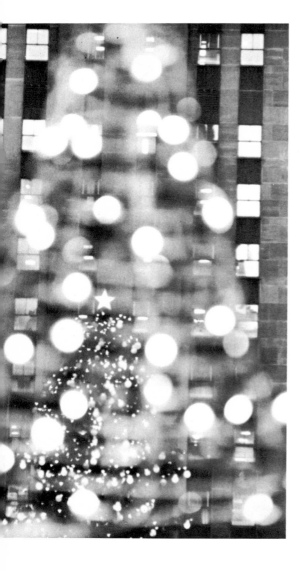

Two Christmas trees in New York's Rockefeller Center merge into a pattern of light in this shot. A 100mm lens was used to enlarge the image size of the further tree. The foreground tree was too close to be included in the in-focus area. It thus became an airy network of dazzling lights. Photo by Horst Schafer.

The light of an amusement park ride and three Christmas trees combine for this shot. A magnifying glass was held in front of the lens to soften focus. A paper doily was added to lend its pattern to each bright light spot. Such creative additions are limited only by the photographer's imagination. Photo by Norman Rothschild.

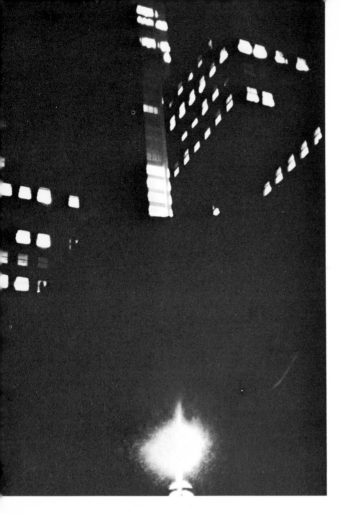

The pattern of city lights at night are the strength of this picture. Such shots are within the capabilities of any alert photographer. Photo by Horst Schafer.

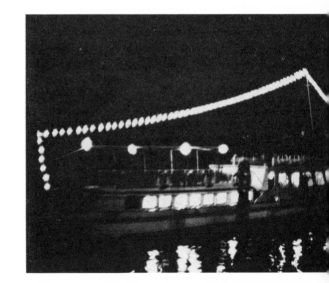

An exposure of 1/8th sec. created this impressionistic shot at Lake Como in Italy. The slight motion of the subject added to the effect. Photo by Kathy Wersen.

A deliberate underexposure of a merry-go-round becomes a study in black and white when printed on high contrast paper. Photo by Kathy Wersen.

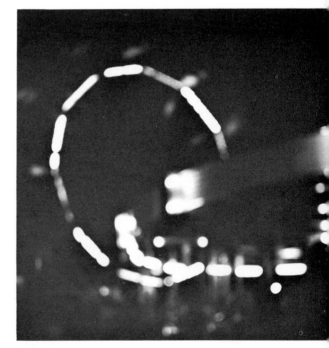

The lights from a ferris wheel and merry-go-round were deliberately thrown out of focus to soften the effect in this ¹/₂ sec. exposure. Photo by Kathy Wersen.

PSEUDO-NIGHT PICTURES

Some of the most dramatic night pictures are created under bright sunlight—a technique long employed by low-budget movie-makers. The trick is in underexposing. The most startling effects come from shooting directly toward or into the sun with a backlighted effect for trees, boats, animals, or people in the foreground. Water which is backlighted turns into dancing diamond-like patterns and all other foreground objects become dark silhouettes. Horst Schafer caught just this in his picture of the swan on page 53, and in his riverscape, page 53. By shooting into the sun over water, Norman Rothschild created the two breathtaking "moonlight" pictures on this page and opposite.

Because of the intensity of light, it is preferable to use a slow film for pseudo-night shots. For example, Panatomic-X rated at 40 ASA will often be exposed at f/22 at 1/1000th. The brighter the light, particularly when shooting into the sun, the higher the camera settings will be. Take a reflected-light reading from the brightest light source in the composition. No other areas matter because they will all become silhouettes. In addition to the meter reading, also bracket several stops less or several speeds faster. You may have to underexpose as much as 8 to 10 stops for the really stark effects. A neutral density filter can be used to cut down light coming into your camera without disturbing color or tonal balance in your picture. These filters come in densities demanding up to a 16× increase in exposure and allow for pseudo-night shots even on high-speed films.

You can also use a red filter if you are caught with high-speed black-and-white-film in your camera and a marvelous pseudo-night subject presents itself. A medium red filter (Wratten A) has a filter factor of 8. This tells you how to compensate for the amount of light the filter holds back from the film. Divide the filter factor into the ASA rating to arrive at the new ASA. For instance, suppose you have Plus-X in your camera, rated at 200 ASA. Divide 8 into 200 and set the new ASA on your meter at 25 to arrive at an existing f/stop-shutter speed combination on your camera. The effect of this underexposure will be a thin negative, similar to those taken at night. Very often, pseudo-night pictures are most effectively printed on the high contrast papers. Experiment to discover your personal preference.

For color pseudo-night shots a gross underexposure shot directly into the sun will produce a basically black-and-white picture. A blue filter used with color film will yield cool, seemingly moon-lit results.

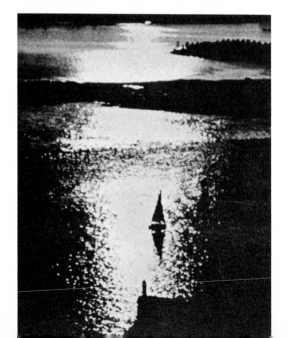

Deliberate underexposure produced this pseudo-night photo. The highlighted water with the backlit silhouetted sailboat produce a moonlight effect. Photo by Norman Rothschild.

A backlit jet taking off against the late-afternoon sun was shot through a medium red filter to enhance contrast. Filters can contribute to pseudo-night effects both by cutting down exposure and increasing contrast. Photo by Gerald Healy, Photo Trends, Inc.

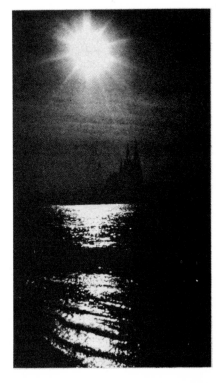

This shot of the Cologne Cathedral was made by sunlight but deliberately underexposed for a night effect. The sun appears as a star shape because it is refracted by the edges of the diaphragm within the lens. This star effect is especially evident at small apertures. Photo by Norman Rothschild.

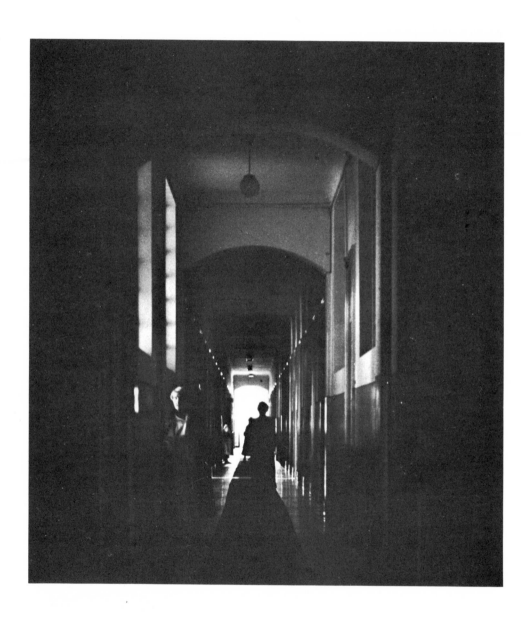

A hospital corridor served as the setting for this dramatic shot. The bright light from the window at the far end served as the light source. Deliberate underexposure of the dark interior created the pseudo-night effect. Photo by Kathy Wersen.

SUGGESTED EXPOSURES FOR AVAILABLE-LIGHT PHOTOGRAPHY

Subjects	ASA 64	ASA 125	ASA 400	ASA 1000
Home interiors with bright light	1/15 sec at f/2	1/30 sec at f/2	1/30 sec at f/2.8-4	1/60 sec at f/4
Home interiors with average light	— — —	1/8 sec at f/2-2.8	1/30 sec at f/2	1/60 sec at f/2.8
Closeups by Candlelight	— — —	1/4 sec at f/2-2.8	1/15 sec at f/2	1/30 sec at f/2-2.8
Brightly lit City Streets	1/30 sec at f/2	1/30 sec at f/2.8	1/60 sec at f/2.8-4	1/125 sec at f/4
Christmas Lights	1 sec at f/4	1 sec at f/5.6	1/30 sec at f/2	1/30 sec at f/2.8-4
Neon Signs	1/30 sec at f/4	1/60 sec at f/4	1/125 sec at f/4-5.6	1/125 sec at f/8
Shop Windows	1/30 sec at f/2.8	1/30 sec at f/4	1/60 sec at f/4-5.6	1/60 sec at f/8
Skylines	4 sec at f/5.6	1 sec at f/2	1 sec at f/2.8-4	1 sec at f/5.6
Fireworks	1/30 sec at f/2.8	1/30 sec at f/4	1/60 sec at f/4-5.6	1/60 sec at f/8
Fireworks (time-motion studies)	5 sec at f/8	5 sec at f/11	5 sec at f/16-22	5 sec at f/32
Floodlit Buildings and Monuments	4 sec at f/5.6	1 sec at f/4	1/15 sec at f/2	1/30 sec at f/2-2.8
Night Football, Baseball, Racing	1/30 sec at f/2.8	1/60 sec at f/2.8	1/125 sec at f/2.8-4	1/250 sec at f/4

POSTSCRIPT

Although night photography requires persistence and practice in interpreting subjects, along with the coordinated use of equipment and darkroom chemicals, you will find it one of the most exciting and creative areas of photography. We hope this book has served to whet your appetite and that future evenings will find the mark of a camera strap on your shoulder.